JOHN ROOD

Sculpture

IN WOOD

The University of Minnesota Press, Minneapolis

Seventh Printing 1973

LONDON · GEOFFREY CUMBERLEGE · OXFORD UNIVERSITY PRESS

This book is for
D.B.A.R.

Acknowledgments

MY SINCERE GRATITUDE to those who, by discussion, suggestions, technical assistance, have had a part in the making of this book. A few of them are: my wife, Dorothy, who has given invaluable assistance; Paul and Carol Kendall, Frank and Beatrice Roos, Laurence and Alexandra Schmeckebier, Theodore C. Blegen, Margaret S. Harding, Jane McCarthy, Mary Lawhead Rood, Peter John Lupori, and many others.

For help in making photographs I am especially indebted to Francis Fuller and Darrell Tom of the Lamborn Studio, Athens, Ohio, and to the Photo Laboratory of the University of Minnesota. Other photographers who have been of assistance are: Winston Weisman, J. C. Merry, Warren Reynolds of Photography, Inc., Robert Nyquist, and Sarah E. Beals.

I also thank Georgette Passedoit, Edith Halpert, Betty Parsons, Curt Valentin, C. Ludwig Brummé, Blanche Dombek, Milton Hebald, Warren Wheelock, Aaron Goodelman, Associated American Artists, for making photographs available to me.

I am most grateful to the Graduate School of the University of Minnesota for a research grant. J. R.

Contents

ART IS WHAT YOU MAKE IT *page 3*

WOOD AS MATERIAL FOR THE SCULPTOR *page 13*

IDEAS AND SUBJECT MATTER *page 27*

TOOLS AND THEIR CARE *page 41*

RASPS FOR CARVING IN THE ROUND *page 56*

CARVING IN THE ROUND *page 69*

CARVING A HEAD *page 89*

CARVING IN LOW RELIEF *page 113*

FINISHING *page 128*

HOW TO USE SCULPTURE *page 152*

APPENDIX *page 175* INDEX *page 177*

PLATES

PLATE		PAGE
1	The Return of John Brown. Oak, 1945	16
2	The Accused. Oak, 1939	18
3	Eroica or Waiting Mother. Walnut, 1942	18
4	John Brown. Oak, 1941	22
5	Mountaineer's Wife. Hickory, 1940	22
6	Casey Jones. Walnut, 1941	22
7	Ossip Zadkine at work on his Christ	23
8	Floating Figure, by William Zorach. Mahogany	23
9	Miners, by Maria Nunez del Prado. Walnut	24
10	Proud Mother. Walnut, 1941	29
11	Johnny Appleseed as a Young Man. Apple, 1941	29
12	The Smasher. Oak, 1943	31
13	Athlete's Head. Ebony, 1941	35
14	American Youth. Pear, 1943	36
15	Boogie-Woogie Boys. Laminated cherry, 1942	37
16	Goin' Home. Oak, 1940	39
17	The studio	43
18	The work bench	43
19	Sharpening a chisel	50
20	Removing the burr from sharpened chisel	50
21	Proper angle for V tool	53
22	An old V and a new one	53
23	How to hold a gouge when sharpening	53
24	Removing burr from gouge with slip-stone	54
25	Riffler files, bastard and rough-toothed rasps	57
26	Torso. Snakewood, 1941	58
27	Big Boss, detail. Walnut, 1936	58
28	Drawing of the design on the wood	59
29	Using the round side of the rasp	59
30	Aaron Goodelman's The Rope. Mahogany	60

PLATE		PAGE
31	Baroque Form. Apple, 1943	61
32	Night Flower. Ebony, 1941	63
33	The Cat. Mahogany, 1938	63
34	The basic shapes beginning to emerge	64
35	A first carving in wood using rasp only	66
36	Bird. Mahogany, 1937	66
37	Horse. Mahogany, 1936	66
38	Salome, by C. Ludwig Brummé. Ebony	67
39	Resignation, by Warren Wheelock. Mahogany	67
40	Defiance, by Blanche Dombek. Walnut	67
41	Drawing, front view, of Sky Gazer	70
42	Jacob Wrestling with the Angel. Mahogany, 1941	71
43	Man with a Rake. Mahogany, 1940	72
44	The drawing of Sky Gazer in reverse	74
45	The drawing, front, traced on block	74
46	The drawing, back, traced on block	75
47	The silhouette cut out	75
48	The figure blocked in, front	76
49	Blocking in carried a step farther	79
50	The back beginning to take shape	79
51	The set of the head, roughly determined	80
52	Revenge, by Ernst Barlach	82
53	Expression of physical tension	83
54	Relationship of forms	84
55	Salammbo, by José de Creeft	85
56	Tumblers, by Chaim Gross	85
57	Acrobatic Dance, by Chaim Gross	85
58	Peasant Girl, by Ernst Barlach	86
59	The Sky Gazer completed, front view. Walnut, 1946	87
60	Back view of the completed Sky Gazer	87
61	The log that Max sent me	94
62	Beginning to carve	94

PLATE		PAGE
63	Difference of expression between two sides	95
64	One of the first faces I ever carved. Walnut, 1934	96
65	Race. Walnut, 1943	97
66	Classical Head	98
67	The same head in terra cotta	98
68	The left side of the head near completion	99
69	Arrogance. Kelobra, 1941	100
70	Side view of the head, same stage as Plate 68	102
71	The features taking form	103
72	Fibrous quality of wood in the head	104
73	View of the head from below	104
74	The Patriarch. Mahogany, 1937	105
75	View of the head from above	106
76	The left eye carved	107
77	Woman with Bare Feet. Mahogany, 1940	109
78	Empty Plate, by Aaron Goodelman	109
79	Closed eyes carved	110
80	The Novice. Tengrung, 1946	111
81	Tiger, Tiger, by William Zorach. Oak	114
82	Mandolin Player. Mahogany, 1937	115
83	Altar piece, Nativity. Mahogany, 1937	115
84	Triptych, The Queen of Heaven. Mahogany, 1937	115
85	Drawing for the Pieta on mahogany block	117
86	Incising lines with the V	117
87	The Pieta, by Peter John Lupori. Mahogany, 1946	117
88	Elephant Form. Walnut, 1942	119
89	Camel. Walnut, 1947	120
90	Tumblers. Walnut, 1947	122
91	Drawing of Tumblers showing movement in space	123
92	The Embrace. Mahogany, 1947	124
93	Homage to Mae West. Walnut, 1947	125
94	Girl with Birds, by Milton Hebald. Teak, 1947	126

PLATE		PAGE
95	The Preacher. Oak, 1939	126
96	Torch Singer. Lignum vitae, 1941	129
97	My Kin, by Aaron Goodelman. Wild cherry	130
98	Nigeria, by José de Creeft. Snakewood	130
99	The Silent People. Pine, 1942	131
100	Laughing Man. Mahogany, 1945	131
101	John Henry as a Boy. Mahogany, 1940	132
102	Cockfighter. Mahogany, 1941	132
103	Accordion Player. Myrtle, 1945	136
104	Slow Dancer. Ebony, 1940	139
105	Young Girl. Apple, 1941	140
106	Caryatid. Walnut, 1942	141
107	Young Brunnehilde. Cherry, 1942	141
108	The Grandmother. Oak, 1940	143
109	Il Pensoroso, by Ossip Zadkine	145
110	Temptation of St. Anthony. Myrtle, 1949	146
111	Leaping Horses. Mahogany, 1949	148
112	The Harp. Myrtle, 1949	148
113	The Burning Bush. Apple, 1945	149
114	Resurrection. Elm, 1944	150
115	Adam and Eve, by Ann Wolfe	154
116	Visitation, by Peter Lupori	155
117	David, by Dorothea Greenbaum	156
118	Flying Figure, by Gwen Lux	157
119	Woman with Hen	158
120	Woman with Bowl, by Evelyn Raymond	158
121	Figure of Child, by William Zorach	159
122	Choir Singer by fireplace	160
123	Choir Singer on hall table	161
124	Choir Singer on bedside table	161
125	Choir Singer in bookcase	162
126	Choir Singer in Italian cabinet	163

PLATE		PAGE
127	Class of '47. Oak, 1947	165
128	Creche. Linden, 1947	166
129	Our Lady of Grace. Linden, 1949	169
130	St. Joseph. Linden, 1949	170
131	Mother Cabrini, by Alonzo Hauser	170
132	Fish. Walnut, 1947	171
133	Sven and Helga. Birch, 1948	172

Sculpture in Wood

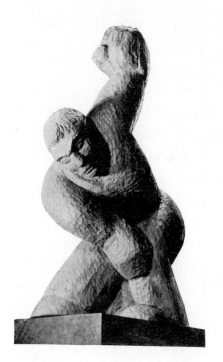

Art
IS WHAT YOU MAKE IT

PROBABLY there is no major branch of human activity more clustered round with barnacles of misunderstanding than the work of artists. People say, "I like art, but I don't understand it." The intimation is that to enjoy a thing one must know all about the materials that go into its making, how those materials are put together, and even to some extent something about the personal life of the maker! This point of view should be extremely flattering to the artist since it seems to imply a very deep interest on the part of people — an interest which I honestly think they have, even though they may not be aware of it. One never hears anyone say, "I like cake, but I don't understand it." People eat cake, usually enjoy it without knowing or even thinking what ingredients or thought went into its making. Perhaps the analogy of a cake and a work of art may seem rather far-fetched, but is it? Each is the product of creative thought working with materials! The making of a cake seems a simple activity. This is because everyone either

3

has made cakes or knows how and where they are made, in kitchens similar to his own. On the other hand, the making of a work of art seems quite remote and mysterious. I believe this attitude comes largely from the fact that the average person has not seen a work of art made. If the making of art were done in everyone's house, I am convinced we would not hear so often "I like art, but I don't understand it."

This attitude is one of the major reasons for writing this book. I should like to take each one of you behind the scenes, not only the actual physical scene of materials and studio, but also into that seemingly mysterious place, the mind of the so-called creative artist. I believe it is possible to do this. If my attempt is even partially successful, it is worth the effort. It is my hope that through this book at least a few of you will become sufficiently interested to try your hand at the making of art, if only as a hobby — just for the fun of it; but even more, I hope that through these pages many of you will gain a little of that understanding and appreciation which will enable you to enjoy art much more fully.

As intimated above, people without realizing it often express their belief that the making of art is of greater importance and value to human civilization than the making of food! Perhaps they are right. In any case, many books have been written on the subject of art but unfortunately too often they are couched in a language that is intelligible only to the expert. Why should not a book on art be as easy to understand as a cook book which can be understood by anyone? I believe it is possible to write such an art book and I am going to attempt to do it simply and clearly. In the end you, the reader, must be the judge of my success or failure.

What *is* the value of art?

Art has no intrinsic money value unless the object is executed in gold or precious stones. The canvas and paint in a picture are worth little; the stone in a piece of sculpture might be worth a little more. To give a homely illustration, you can't weigh art on scales, like butter, and sell it across the counter. Then perhaps you will say, if art has no material value it has no value at all. But is this true? Let us ask other questions: what is the value of

4

religion? What is the value of faith, of love, of understanding? I am sure you will not answer that these have no value. Then if you understand that these *have* value beyond dollars, you are well on the way to understanding the value of art.

Art, like religion, faith, love, understanding, is a necessity for the human being; without these we would quickly destroy ourselves. The necessity to create which is inherent in sculptors, painters, writers, musicians, architects, is and always has been one of civilization's greatest assets. This creative urge is recognized far too rarely and when recognized, it is often in a negative rather than in a positive way.

And the function of art: what is it?

Art is not functional as a dishpan is; it is not a necessity as we conceive the automobile to be. The dishpan and the automobile are functional on a material level. Art is functional on a spiritual level. On the material side we are animals; we must have transportation, houses over our heads, enough food to eat, and so on. On the spiritual level we must *be* human beings. And for some strange reason it is necessary to iterate and reiterate that we *are* human beings and to prove it again and again. Each generation has to prove it—the proof of former generations will not do the trick for subsequent ones. This is a nuisance to a civilization that believes as ours does in "progress." There is no "progress" in religion, in love, in art; there is only reiteration, dedication. The cave man making his drawings and carvings on the walls of his cave was almost as advanced in art as we are. We have learned a few technical tricks: perspective, color relations, and so on. But we are doing the same thing that the cave man felt he must do, and that was to create in order to show that he possessed a spiritual quality which the animals about him did not have. To satisfy his spiritual hunger, the cave man created beauty; he wished to have a kind of immortality, hence he made his marks on the walls of his home, thinking that these would remain when he was gone. The making of these images was religious in nature. The making of images today is equally religious in nature, for it satisfies a spiritual craving that is in us. As Eric Gill said in one of his essays, God created the world and all that is in it, but He did not complete

the job: He gave man the capacity to carry on where He left off; thus when man creates, he becomes as it were, extensions of God's fingers. Although many of us are not, in an orthodox way, as religious as Eric Gill, his explanation of the necessity for creation appeals to me as being a simple and a very good one.

The value of art to us should be that it is the greatest key we have to the understanding of one another. And it is through understanding others that we, as human beings, can perilously skirt the chasms of brutality, war, nihilism. Art is the great international language; it knows no barriers of race, religion, country. And it is through man's creations in the arts that we best arrive at an understanding of the civilizations of all ages.

What does art make us understand?

It makes us understand that we human beings are prone to err, that we are not and cannot be perfect; it makes us understand that the perfection of the material world is not for us. The man-made thing, art, can never be perfect; the machine-made thing can be — with all the dullness that goes with inhuman perfection.

But perhaps this is too abstract; let us get down to instances. A washwoman drawn by Daumier gives us in pictorial terms an understanding of the woman's life; we feel her tiredness, the endless round of drab activity. Without a word of explanation we understand that probably she has many children at home to be fed, that perhaps she has a drunken husband who will not provide for the family; hence she must take in washing. We understand her problems — at least all that our imagination will allow us to comprehend. Thus, you see, we, as observers, become a part of the creation of the artist, for without our understanding his creation is not complete.

Paintings such as the prostitutes of Toulouse-Lautrec make us understand the depths of degradation to which the human animal can descend. And, at the same time that we look at them with fascinated distaste, they make us realize the imperfection that is almost the essence of humanity. But always, always, we must look with our imaginations: we must enter into and become a part of the creation of the artist. He has done his work, but that work is only as good as we with our cooperation will allow it to be.

6

By this I mean that the artist does not work in a vacuum, snatching his ideas from some mysterious void. He is not a magician though sometimes his work seems so wonderful that he would appear so. The artist is a man with heightened perception, able to put into material form the dreams, aspirations, feelings that are common to all of us. But because he is especially aware of gradations in sensual perception and is able to translate them into forms or words we all can see and hear, we are apt to feel that he is set apart, that he is not as we are. Consequently we are almost afraid to go along with him in his discovery and presentation of new worlds of perception and thought. Most of us, unfortunately, are like ostriches: we prefer to ignore things which frighten us or which we find difficult to understand. But we are not ostriches and should not act like them. We are human beings with minds and perceptions that must be used if they, like tools, are to be kept sharp and bright.

The parable of the talents is very applicable. If we refuse to use our minds, to develop our senses and perceptions, they will gradually atrophy and eventually disappear! And this applies distinctly to understanding a work of art. We are not talking about the insipid calendar picture. Anyone can take that in at a glance — it does not require study. As a result one soon tires of it. However, the real work of art, like the Toulouse-Lautrec painting, cannot be understood at a glance, often not in many glances! It requires concentration and thought as well as sensual perception to comprehend fully what the artist wished to convey. He has done his work, has put it before us, but until we have seen not only with our eyes but with our minds, until we have tried to absorb the meaning of the artist and succeeded at least to a certain extent, the artist feels that the function of his work has not been fulfilled. And as for us, the observers, the more a work of art demands in thought and perception, probably the greater that work is; certainly the more we understand it, the more we will enjoy it.

A novel such as *War and Peace* has many avenues of understanding. It is as up-to-date now as when it was written, even though it was written in the time of emperors and political systems which are practically nonexistent today. Every generation needs its *War and Peace*. Perhaps if previous

generations had produced more such novels the words war and peace would be archaic, or at least not so constantly in use.

Take a work such as Beethoven's Sixth Symphony. What do we bring to the performance other than the sensual ability to have our ears pleased? Here again is a universe. It is not a universe of words, but one of sound. Who can listen to it, or to the dozens of its symphonic counterparts, without a quickening of the whole human being? We enter into a new world; our senses are heightened, we breathe more deeply, we are proud to belong to the same human race as the man who created this. Again, the music is as great as our imaginations will let it be.

Knowledge and understanding of older civilizations are best given us through their arts. For instance, think how much we learn from the excavations of Pompeii and Herculaneum of those two overlapping cultures, the Greek and the Roman. The very walls and columns, the architecture, explain to us their way of living: from the wall paintings we learn of their festivals, daily activities, customs, mores. Their gods even are brought close to us as we see them depicted in sculpture, so that Zeus and Aphrodite and Apollo and Diana mean more to us than mere words. And we can see here the difference between these two cultures — the Grecian simplicity and gentility which the Romans could never quite attain, crushing out the lyric essence as they tried to lay hands on it. In short, we learn the real history of these people — their spiritual history, beyond the factual statement of dates and happenings — through their art.

Now it happens that although I do some painting, I am first of all a sculptor. So naturally in this book I am concerned with sculpture, and specifically with sculpture in that most simple of all materials, wood. I believe sculpture is the art which people respond to most naturally — they can take hold of it; they can enjoy it with the sense of touch as well as the sense of sight and they can enjoy it from all sides.

I admit that at this particular time sculpture seems to occupy second place in the art world. How often in art journals it is referred to as the "stepchild" of art! But sculpture has not always taken second place. In

8

those periods generally recognized as the "greatest" in the production of art, sculpture might be called the backbone. Certainly it was the major art. This was true of the Egyptians. Their architecture, the pyramids and the temples, was itself a form of sculpture, and designed to house sculpture. The Greeks: their temples and buildings were made of hand-hewn, that is sculptured, stone. Outside they were often adorned with sculpture and much was placed within. Fortunately many of these noble figures remain for us today and tell their story of the Grecian love of beauty and the worship of their gods. The Gothic cathedrals, the glory of medieval Europe, were built of carved stones fitted together, making a gigantic piece of sculpture which in turn was embellished still further by sculptured figures. And in the Renaissance even the painters thought sculpturally. Think of the great sculptural figures which Michelangelo painted in the Sistine Chapel, paintings which not only influenced the artists of his day but have been studied ever since.

Let us look in another direction. What would we know of the Mayan, the Aztec, the Inca, the Toltec civilizations if sculpture had not been the chief art of those peoples? Most of their written records have been destroyed. Their history remains for us in their sculpture. This is almost as true of the early history of China, India, and the Malay peninsula. Here again we have the sculpture of their gods gazing at us down through the centuries, telling in no uncertain terms of the serenity of these people and their contemplative nature.

Now let us look at our own time. Why is art so spineless, so lacking in virility, so showing-at-the-edges of decadence and neuroticism? I can almost hear the great sculptors of the past crying down the ages, "Where are *your* sculptors?"

Our musicians turn their basically emotional and romantic art into a dull cerebral business which is mathematics made audible, scientific and inhuman. Writers play with words, forgetting that the function of writing is to communicate ideas simply and clearly. Painters quarrel about non-objectivity and abstraction, regionalism, naturalism, and fly off into fantasy which too often has no substance other than perhaps something called

9

"paint quality"—and heaven knows a painting must certainly have that, but should that be an end in itself? Sculptors are busy hunting for boulders which they can place on stands after the minimum of cutting, or they try to mystify us by making weird constructions of stone or wood or metal which often move into accidental designs when pushed, or which can be taken apart and reassembled to make "interesting" designs. It is art, of course, and it is all right as far as it goes. But why are most of our artists afraid to speak out clearly so that even the simplest person can understand? People with some knowledge of art, when faced by a painting or a piece of sculpture that is completely incomprehensible except as a design, are apt to murmur, "How interesting!" They do not like to say flatly, "That is nothing," for in the past critics too often have been wrong in their judgments. But the general public is frankly bewildered and honestly says so!

A great deal of the fault for this bewilderment can be traced to the artists themselves. One reason for the present confusion is that most of our young artists will go to any extreme to escape being considered provincial, regional, or worst of all "academic." They do not realize that their concept of academic (that is, the dull and pedantic realism of the nineteenth century) has been dead for a long time. Neither do they realize that they are in the center of another kind of academism just as stultifying as the thing they think of as "academic." The present academism is quite as dogmatic as the old, and perhaps lays more of a dead hand on the student for the very reason that it *seems* to give free rein. The student is encouraged to experiment with tools and materials, to follow his own imagination, and is not forced to copy painfully every curve and shadow of a vase or plaster cast and thus learn the basic principles, from which eventually he may soundly develop his own ideas and style.

As for the fear of provincialism or "regionalism," which is common to most of our artists, young and old, and particularly our American artists— why be afraid of that? Let us be honest about this. To escape being called "regional" or "national" or whatever the term may be, American artists will accept any formula lately imported from elsewhere, but usually from Europe, overlooking the fact that the formulas they accept were in their be-

ginning quite as "regional" as ones they might develop for themselves! For what artists could be more "regional" than El Greco, Cézanne, Rouault, Picasso, Matisse, Beckmann were in their day or are now? We do talk about what we call the "international style," but that style — the same as the style for women's clothes — is mostly created in Paris. Also let us remember that even should a foreign style be adopted, one does not need to take over the subject matter on which that style was first used.

What we need to remember most is that great art must come from a place, and that place is where the artist lives. The artist must look inside himself, he must look at his own background, his own surroundings. If he finds nothing there of enough interest to make him want to cry out his message, he will never make much of an impact on the world. He is not going to find his material by searching the world for things unusual and different and alien to him. He may make a bizarre little place for himself but that place in the world of art is comparable to those bizarre "Turkish corners" in pretentious houses of the nineties!

Again referring to the so-called international style: isn't it enough that art is now and always has been the only international *language*? Must we all speak with the same inflection; that is, use the same style, in order that we may be understood? Obviously not. We understand the peoples of Egypt, China, Peru, Mexico, Greece, medieval France, because of their sculpture, and that sculpture speaks the same language with varying accents — but all of them we can understand fairly easily, even though their voices may be as different as, say, French and the grunt of the cave man!

In conclusion, what I am attempting to say is this: art is a language that can be understood by anyone in any time. In the United States, up to the present time, we have been rather apologetic about our art. We have accepted the dictum of Europe that there is little in the way of art in this country worthy of attention. Let us be honest about this. There is really no reason for us to hang our heads in the world of art. Of course in this book I am pleading a special case for sculpture, particularly for our native sculpture. I believe that we can earn great respect for American sculpture, espe-

11

cially for sculpture in that most native of materials, wood. We have great forests of beautiful woods. We have a culture and a subject matter most eminently suited to wood. Let us look into ourselves, into our traditions, our customs, our lives, our localities; then let us take the tools and the material with which we are so familiar and go to work — and not worry too much that we may be out of step with what appears to be the main current, or that what we are doing may not seem to have great importance. That in time will take care of itself. If we work honestly and sincerely, it may well be that we can create an era of great sculpture which through the ages will portray the lives, the aspirations, and the spirit of this country in the twentieth century.

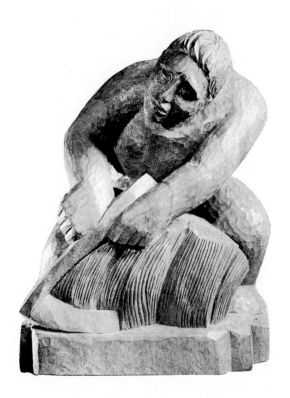

Wood

AS MATERIAL FOR THE SCULPTOR

THERE IS not as much difference in the materials, stone and wood, as you might expect. Stone requires less immediate skill but more patience; wood is quick, but you have to be on the job every minute else it will get out of hand. There are few long, dull periods when you merely spend time removing excess material. Wood is more direct than stone and one has less time to make decisions.

Aside from this, wood is the material that most of us understand in our "bones," for we have lived more often than not in wooden houses, sat on wooden furniture; we have known the feel of wood under our hands as long as we have known anything. Therefore for us it is not as alien a material as stone. This feeling, I am sure, is common to most Americans, except perhaps for the coming generation who are growing up used to machine-worked metal and plastics. I, for one, do not welcome the day

when we ride in cars, live in houses, eat food, wear clothes — all made from synthetic materials.

Not long ago I spent some time with one of our foremost medical men, and we were talking about the world in general. He gave his opinion that we had reached the peak in our mechanical civilization, pointing out that if we went much further our civilization would destroy itself with its own machinery. Not only the machinery of obvious destruction — guns, airplanes, tanks, and so on — but also the machinery that might go under the general heading of gadgets. We were having dinner in an ordinary restaurant of the sort to be found in any small town. He called my attention to the dozens of mechanical contrivances in that one room. There were orange squeezers, milkshake machines, electric toasters, waffle irons, coffee-making machines; all the numberless contrivances for lighting and manipulating advertisements, the inevitable radio, and a complicated arrangement for making music by putting a coin in a box on your table and pressing a button — at the moment it was reducing Chopin to hogwash; there were automatic cigarette and match vendors, pin-ball machines in which lights flashed and bells rang, and so on and so on. The place was a maze of contrivances for assaulting the ears and eyes of the customer, and a maze of machinery for preparing food to insult the sense of taste and smell. The doctor said that anybody with common sense knew that we could not be so constantly surrounded by these sensual agitators without having some harm done to our nerves, or at least without having our senses so dulled that only the loudest noises, the rawest colors, the sharpest tastes would catch our attention.

We do need to get closer to the actual substances, the more subtle sensual perceptions, that go into the making of us, body and soul. Our writers, painters, sculptors, musicians, architects, dancers have, in their several ways, been saying this for many years. We need to handle the juices, meats, vegetables that go inside us; we need to listen to music at the source, made by men in the same room with us; we need to touch, and to be repelled or drawn toward trees and rocks and earth, if we expect to keep ourselves sound and healthy in mind and body.

14

As a youngster I carved with a knife a few small heads out of very tough yellow pine. This was not the usual sort of whittling, it was small sculpture in the round. Yellow pine is not the most tractable of woods and my knife was not too sharp, consequently I remember this experience as one of cut fingers! A few years later, left alone in a woodworking shop at Langley Field while some aviator friends made a flight, I found a small piece of poplar and some chisels. I passed the time carving a head out of the poplar and got a great deal of satisfaction from it. But it was not until the fall of 1933, after a summer in Europe, that I really began carving in a serious way. During my stay in France I had seen examples of a local carver's art. For the most part they were rather insipid imitations of the carving done at Oberammergau — which carving seems to me somewhat sentimental and lacking in virility. I knew that I could do better — by which I mean that I felt I could carve figures with more vitality, figures better suited to the material. The local carver obviously knew his craft. I realized I might not have as much technical facility, but I felt it was unfortunate that he had nothing to say with his wonderful technical ability.

When I arrived home, I looked about for tools and a place to work. In the basement of our home, which had belonged to my wife's grandfather, I found a small workbench equipped with a wooden vise, and in the tool rack were a few wood rasps, files, and a chisel or two — just as the old gentleman had left them, except that now they were covered with the dust and debris of neglect. There were carpenter's tools, and there was even a mallet. In a corner of the basement, among other pieces of wood, was a small square block of oak. Being more than half Celt, I must admit to more than a half belief in signs and omens! Certainly here was a perfect set-up for an amateur carver.

Oak is not one of the easier woods for a beginner. However, in my ignorance, I began work on the block. The rather simplified head that I wanted to make was quite clear in my mind and so I completed the head quickly, though crudely to be sure. It was a case of mind over matter, and very stubborn matter at that!

The beginning, for me, was that simple. I added a few more carpenter's

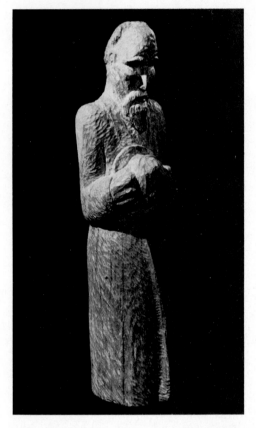

Plate 1. The Return of John Brown. Oak, 1945. 39 inches.

tools to my meager equipment, but I had my first one-man exhibition before I learned where to go for professional carver's tools. To this day I find that the simple carpenter's chisels and gouges in my kit are the tools most often used.

But to get back to wood as a material for the sculptor: almost the first question people ask me is, "How do you keep it from cracking?" The answer is, I don't. The natural tendency of wood in the log, when it dries, is to crack. This is obvious, for wood dries from the outside in — the outer part dries, contracts, and naturally splits. This continues until the wood is dry through to the core. Then quite often the shrinkage of the inside draws the outside layers together and the crack is closed.

The tendency of wood to check or crack is, frankly, a fault of the material. However, if the sculpture is properly designed, the cracks may even enhance the appearance of the piece — Plate 1, The Return of John Brown, for instance. After all, cracks are the nature of the material and also a part of its fascination. Wood is alive! It has spring, "give," and so long as it does not rot away into dust, it has a vitality of its own: constantly contracting and expanding with varying moisture, heat, dryness, cold.

16

"Yes, that's very interesting," prospective purchasers say, "but what if it just falls apart?"

Have you ever seen a piece of wood that fell into pieces of itself? I haven't. Of course if rot sets in, that is something different. A way to reassure yourself is to go to the nearest museum and look at the sculpture in wood that was made in the Middle Ages and compare it with the stone from the same period. You will find the wood is in just as good a state of preservation as the stone. Ears, noses, fingers, toes have very often been broken off the latter, whereas the wood is in pretty good condition unless rot has attacked it or it has been for too long exposed to the elements. Some museums have wood sculpture made by the Egyptians long before the time of Christ.

But even if the material could not possibly hold together for more than a thousand years, isn't that long enough? Today any work of art worthy of preservation can be preserved, for it can be reproduced, photographed, and the record kept. Personally I cannot understand the desire on the part of artists that their work last forever: it presupposes an importance which most often is not there. No artist would deliberately choose materials that will not survive and if he is reasonably careful, his work will last long enough for it to have its influence and if time proves it to be worthy, you may be sure a way will be found to preserve it.

If a piece of wood on which you wish to work has cracks that distress you, there are, in the chapter on Finishing, directions for filling them. In the main, however, I would take wood as it is — its faults with its virtues.

What for the sculptor are the special advantages of wood over other materials? The most obvious is that wood is available in any part of the country. Any lumber company has a few pieces of wood of proper thickness, and almost any wood can be used for sculpture. Or, you can always find pieces of firewood. Some of my best sculpture has been made from lengths of wood found on the woodpile. The Accused, Plate 2, was carved from a piece of oak intended for the fireplace. In fact, this is one of the best sources of supply that I know! Living as I did when I began carving, in a small Ohio town, I called a farmer and asked him to bring me a load of fire-

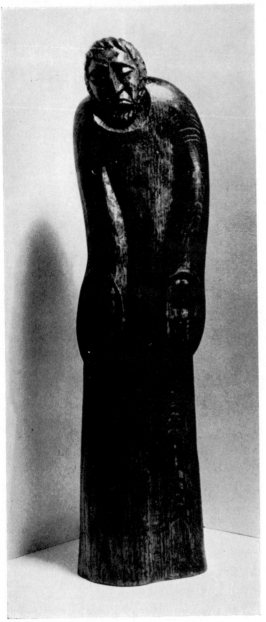

Plate 2. The Accused. Oak, 1939. 24½ inches.

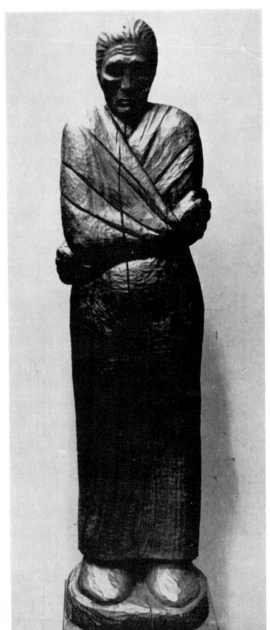

Plate 3. Eroica or Waiting Mother. Walnut, 1942. 6 feet.

wood. Invariably there were lengths of cherry or oak or walnut in that load. Later I asked if he had any logs of these woods and when he said yes, I asked him to deliver the wood in the log. I got beautiful woods for the cost of firewood and the farmer was quite happy about it for he did not have to go to the trouble of cutting the log into suitable lengths for the fireplace! Eroica or Waiting Mother, Plate 3, was made from a walnut log obtained in this way.

There are many other advantages to wood. It is easy to handle, and this ease of handling is really a great advantage to the sculptor — especially after he has wrestled with stones, which are heavy even in small masses! Wood is easy to carve; that is, it cuts easily, though as I have pointed out before, this ease of cutting forces one to keep his wits about him.

Another advantage is that sculpture in wood fits most readily in the home. There is a wide range of colors and textures. The colors are pleasing: warm, vibrant, alive, and the surface of the material is pleasant to the touch. Perhaps it would be well to say here that wood sculpture *should* be handled. Often when my work is exhibited I see signs saying, "Do not touch, please." This is too bad. Half of the pleasure of owning sculpture is the tactile pleasure derived from passing one's hands over it. And it is good for the sculpture, for there is no patina comparable to that obtained by the touch of the human hand. Think of the beauty of the wood in old plow handles, the arms of chairs, table tops, which have known the touch of human hands for years and sometimes generations!

And yet another advantage: one reason sculpture is so rarely exhibited is that it is difficult to ship. Stone and bronze are quite heavy. They have to be carefully crated, and if you have ever seen a half-dozen men heaving away at a ton or so of carving, you realize why museums and galleries are so reluctant to exhibit sculpture. But consider wood: it is light, if reasonably well packed it does not mar, if properly designed there is no part that will easily break off. A large exhibition of wood sculpture might not weigh as much as a single work in stone or bronze! For the past several years I have had an exhibition of fifteen pieces of sculpture, circulated by the American Association of University Women, which is packed in one large wooden

19

crate. The whole thing weighs about 250 pounds. The express charge for short distances between points of exhibition is less than ten dollars. Hence with very little expense my sculpture has been shown in communities which never before had seen original sculpture: thus in these towns for a couple of weeks, high school students interested in art have had the opportunity to handle and study original work. I like to think that when my sculptures are being shown they are working, functioning; that people are deriving pleasure, or at any rate interest, from seeing them. In other words, they are fulfilling the function for which they were brought into being. You can easily see that I believe works of art should be exhibited as much as possible. This fact alone, the greater ease with which wood sculpture can be circulated, is enough reason for carving in that material.

But for me there is another reason, a quite personal one, one which I feel might very well be considered by more artists in America. For too long most of our sculptors have been concerned with every subject matter under the sun except their own. If our writers used ancient Greeks, or the mythology of other lands, for their main subject matter, what would we think of them? And yet, our sculptors in the past, and often in the present, do just this thing. I will not say that a torso is the sole property of Greece, for the original idea of torsos came from accidents which happened to sculpture. Heaven knows there are torsos and to spare in practically every group exhibition of sculpture! The torso is a beautiful thing, naturally every sculptor wants to have a try at it, but as one great contemporary sculptor said to me, "*Everybody* makes torsos." It does take more ability, both physical and mental, to create a full figure with head, arms, legs, properly designed in the material so that no part will break off, than it does to create merely a central trunk. A torso alone can be a quite beautiful thing: sensual, exciting. But it cannot say much to our minds: it cannot give us much understanding, and this understanding, as I tried to explain in the preceding chapter, is one of art's great possibilities.

But to return to my personal reason for working in wood: I feel that I, as an American, with my roots here, with my knowledge of American people, should have something to say about these people I know. It is not

enough for me to make pleasant and even exciting patterns in wood that will provide pretty decorations for the homes of the few who can afford to buy them. Art is an important thing, but it is important only if we take it seriously and treat it with the dignity it deserves. This does not mean that works of art need to deal always with ponderous subject matter — an angel turning a somersault can be as serious a work of art as an angel flying in the usual manner! It happens that I want to say something in my work about people whom I have known; about their beliefs, their customs, their actions, their mythology. Now these people come naturally from that part of the country where I have spent most of my life — the Ohio River valley and Minnesota. I never understand why this great midwest of ours strikes many newcomers as hideously raw, gauche, ugly. They never seem to see below the surface. To me we have here a special kind of strength and poetry that spells the United States of America! Sherwood Anderson felt that strength and poetry and put them into words. So have the many other writers from the great midlands: Willa Cather, Carl Sandburg, Sinclair Lewis, Booth Tarkington, Edna Ferber, to mention a few. Frank Lloyd Wright has built the same thing into his architecture. Thomas Hart Benton, Grant Wood, and others have painted that strength and poetry. In fact I believe that the arts generally have been enriched by midwesterners carrying with them the spell of the land from which they came.

Now it might seem difficult to bring the special flavor of the midwest into sculpture. But to me, the obvious way to translate into my work the poetry that I feel is to portray the characters I have known and portray them in the material I know best, that is, wood. For instance, what would you do if you wished to make a figure of Daniel Boone? Would you choose bronze or stone as your material? Do you think either would be as suitable as wood? Obviously not. And having decided on wood, would you choose oak, walnut, cherry, apple, cedar, pine, hickory, butternut, pear — aren't they beautiful words? I would choose oak — a coarse-fibered, grainy, tough oak, with all its tendency to crack. And if I were doing John Brown (Plates 1 and 4) I would again choose oak. For a mountaineer's wife (Plate 5) I chose hickory. Why hickory? Because it is a tough, springy, enduring wood.

21

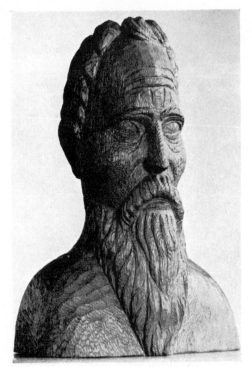

Plate 4. John Brown. Oak, 1941. 19 inches.

Plate 5. Mountaineer's Wife. Hickory, 1940. 19 inches.

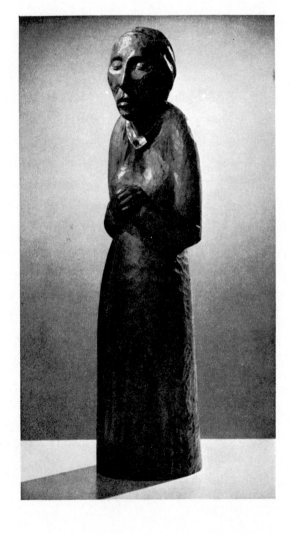

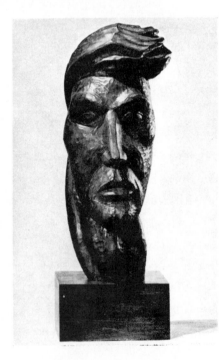

Plate 6. Casey Jones. Walnut, 1941. 19½ inches.

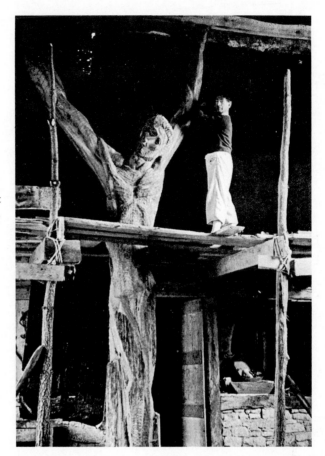

Plate 7. Ossip Zadkine at
work on his Christ.

Plate 8. Floating Figure, by William Zorach. Mahogany.

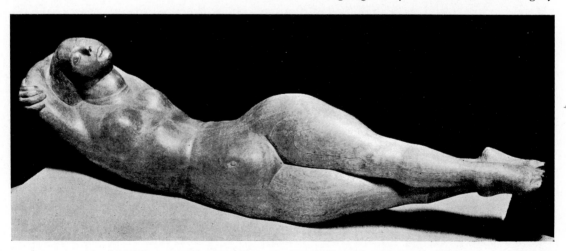

Plate 9. Miners, by Maria Nunez del Prado. Walnut.

For Casey Jones (Plate 6) walnut was the right wood, as I wanted the dark color which somehow carries the implication of tragedy and gives to the head a somber, almost Indian quality.

Can you imagine any of these sculptures executed in any other material? I believe wood is the material these people knew best and loved and used most.

Now let us look at some sculpture in wood by other sculptors and see how well they have adapted the material to their subject matter.

Plate 7 shows Ossip Zadkine at work on his large Christ, treelike in form and as you can see, carved from a tree. I was amused when this photograph came to me, because Zadkine said to me once, "Ebony is the only wood suited to sculpture." The figure of Christ is probably elm or some such wood — surely more appropriate to the figure than ebony!

The original shape of the piece of wood may have suggested the Float-

24

ing Figure, Plate 8, to William Zorach, but can you imagine this work being so effective in another, heavier material? Wood floats: stone and metal do not.

Miners, Plate 9, is by Maria Nunez del Prado of Bolivia. She came to an exhibition of mine some ten years ago. She had just arrived in this country on an AAUW fellowship for study and work. My exhibition that year was made up mostly of what I call my Folk Music series — of which John Brown, Casey Jones, Johnny Appleseed, and Waiting Mother are examples. Miss del Prado, a dark, handsome girl, came into the gallery and went from one piece of sculpture to the other, pausing much longer than the usual visitor to examine each figure. Someone introduced me to her and she turned her dark shining eyes to search my face, saying "You are the artist." I nodded. Her eyes were perhaps more eloquent than her words, for she spoke at that time in broken English, when she said, "This is what I want to do for my country, The Indians, the people — I want to help them." At that time I had seen none of her work. Since then I have seen perhaps a dozen pieces of which "Miners" is an excellent example. Miss del Prado at that time worked mostly in wood. Notice how eloquently she has used the material; how the design suggests a cross. Wood is the material from which the cross of Christ was made. Hence, in a subtle way, the sculptor through her choice of material has given added meaning to the subject portrayed.

Now every civilization has its own mythology, so intertwined in the cultural background that one is scarcely aware of it. I use the word mythology in a different sense than that of a mere collection of fables; in the sense of symbolical significance or meaning. Thus the cowboy in his high-heeled boots and chaps as he stands against a rail fence rolling a cigarette; two women gossiping over a back fence; the mourner's bench at a country camp meeting; the soda jerker seen in our Main Street drugstores, and even Main Street itself! All these and hundreds of counterparts make up what we think of as "typically American." They have become a part of our mythology, in the sense that they have symbolical significance, and it is that mythology so essentially ours which I feel provides an unusually rich cultural back-

ground for our artists. We Americans of the United States are an earthy people in spite of the fact that we are probably technologically the most advanced in the world. Our humor, our stories — whether the Pullman car variety or the rather innocent backwoods tale — are earthy; underneath the exterior of a nation which seems to be made up of traveling salesmen, docile and stereotyped, is a nation of people who are anything but docile and stereotyped! For we are a young people, full of salt and gusto; we dare the impossible because we don't know too much — we are not vitiated with cynicism; we may not have the graces of the European salon, but we do have the energy and the know-how of the kitchen, the laboratory, the farm, the factory.

All this may sound like the veriest jingoism, but for the artist, who interprets best what he knows best, there is not the same danger in exalting the place and time in which he lives as there might be should a politician, in his field, do the same thing. The artist creates not just for his immediate time and contemporaries, but for all people of all time. In other words, the artist is dealing with universal meanings and truths, whereas the politician is more often than not merely striving for immediate power, and misrepresentation, for him, is often more valuable than the truth.

What I have been trying to say in these past few paragraphs is that we in this country are blessed with an unusually rich background and wood seems to me the material peculiarly suited to its portrayal.

Ideas
AND SUBJECT MATTER

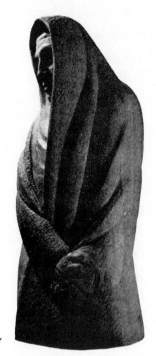

ONE OF THE questions most often asked me is, "Where do you get your ideas?" Well, there is no storage bin of ideas to which I may go and make a selection. At times ideas come from everywhere and anywhere — the shape of a tree, a glance from a fellow bus passenger, the slouch of a figure, a musical phrase, a picture in the newspaper, a character in a book: these are the sparks that often light the tinder. Then there are other times, those terrifying and dull periods known to all creative workers, when nothing comes.

Here are some pictures. In each case I will tell you where I got the idea for the sculpture. Praying Woman, shown above, had been in my mind for some time; that is, I had the general idea of portraying a woman under terrific strain, numbed by the shock of great tragedy, such as the loss of an only son in the war. I knew that the face must be calm, as if the emotional storm had passed, and yet I wanted a certain agonized tension in the sculpture, the greater agony that comes later, after tears have passed. One day in glancing through some old magazines I came across a picture of Ruth

27

Draper with a shawl over her head. There was the form that I wanted my praying woman to take. I set to work immediately on a huge block of oak — the figure is over life-size — with the design as clear as crystal in my mind. The face was to be filled with a certain resignation, but the hands were to be gripped so tightly together that the tendons would stand out. It is this play between hands and face, and the design which leads the eye from one to the other, that give the figure whatever power it has to move you.

An entirely different thing is the Proud Mother, Plate 10. I was walking down the street and saw two women standing together in a doorway talking. One of them held a baby in her arms; the other was saying in that special sort of tone reserved for babies, "My, but he's a sturdy little man!" The mother, her face full of pride, looked down at him as if she was in full agreement with the praise. This chance meeting happened during one of those dull periods of which I spoke. I hurried home and set to work.

Johnny Appleseed as a Young Man, Plate 11, is a natural — that is, it is a natural subject for a sculptor in wood, and more particularly apple wood. Strangely enough, though I was doing the Folk Music series at the time, I had not thought of carving him. I had done Paul Bunyan and John Henry, legendary characters from other parts of the country, whereas Johnny Appleseed belonged mostly to that part of Ohio in which I was then living and where I had lived most of my life! Charles Allen Smart was visiting in the studio one day and, glancing up at the Paul Bunyan mural which filled one entire end of the room, said quietly, "I'll never quite forgive you for your interest in Paul Bunyan until you have done something with Johnny Appleseed. In fact, knowing you, I can't understand why this great interest in Paul Bunyan. After all he is a symbol, more or less, of the wanton destruction of our forests, whereas Johnny Appleseed planted trees." Allen had a story on Johnny Appleseed that was published about that time in the *Atlantic Monthly*; then another writer friend, Harlan Hatcher, devoted a chapter of his book *The Buckeye Country* to Johnny.

I was intensely interested in the idea and yet I could not "see" in my mind how I should carve him. The usual word picture of him, a man half crazed, wearing an old burlap sack, a sauce pan on his head for a hat, did

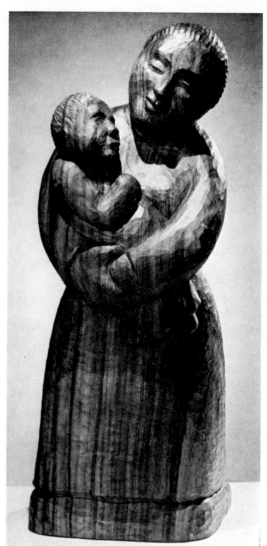

Plate 10. Proud Mother. Walnut, 1941. 18 inches.

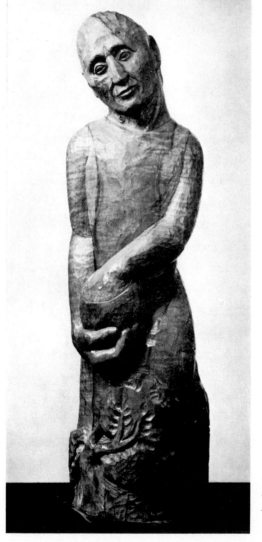

Plate 11. Johnny Appleseed as a Young Man. Apple, 1941. 31 inches.

not strike me as right. And the idea of his being a sort of midwestern version of St. Francis of Assisi, preaching to the Indians, the birds, doing good works, also struck me as being too pat, too easy. And then a chance remark set me off. Several people were in the studio and I mentioned Johnny Appleseed. Perhaps it was my good friend Paul Kendall, or his wife Carol — I do not remember, but surely they were present since they have set me going on many projects. Paul said, "We always read about him as a man in his prime, or as an old man. I wonder what he was like when he was young?" That was it! Johnny Appleseed as a young man, the dream of what he might do showing in his face. And so I tried to carve him; his hand dipping into the bag of seed, branches of apple trees growing up about him as if he saw them in a vision.

Then The Smasher, Plate 12. I cannot remember the exact incident, something that happened locally, but I do remember the face of the man who set the idea in my mind. He was a humble man, a miner or a janitor or a garbage collector. All I remember is the face. He had been unjustly reprimanded — the sort of thing that happens: a stupid though powerful person, showing off his power, playing the petty tyrant. This man had just been the victim of such a person. He looked up and in his face was indignation, hurt, resentment. And the thought flashed into my mind, "That's the sort of thing that makes revolution. Drive that man a little further and he will strike back with anything he can find — a rock, a hammer, a pitchfork — and the ones who have really started it, the stupid, the powerful, the arrogant, will cry out at his brutality!" Thus I carved The Smasher. Many people have commented that he has the jaw of Mussolini. Sure enough, he has, though it did not occur to me while carving. Later I carved another Smasher striking with his bare fists, and later still another, with a great rock, which I called Guerrilla.

These are enough examples to show you how ideas have come to me — as they do to any artist. It makes for an exciting life: no incident, however slight, passes unnoticed. You will be forever trying to see behind the incident, striving to understand; your mind has to be, and is, alive.

One gets the germ of an idea, often it is a fragmentary, slight thing that

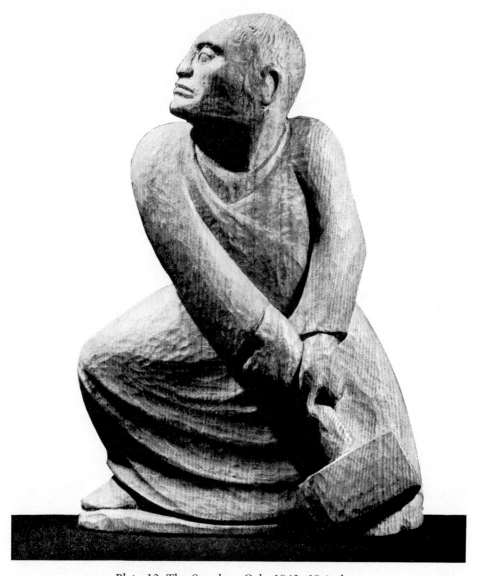

Plate 12. The Smasher. Oak, 1943. 18 inches.

glances into the mind and you think about it for a moment, then cast it aside — except that you really do not: it sticks, and gestates. Days, weeks, months, or even years later the idea comes back, strengthened many times, and by then it has taken shape and that shape fixes itself so strongly in your mind that you feel impelled to put it into lasting form. After you have finished the thing, it then begins its own life and you go on to other things, sometimes almost forgetting it. Occasionally I see a piece of sculpture that I made some years ago and cannot remember why I did it, nor can I feel any kinship to it. Sometimes it strikes me as being better than what I am doing at the moment. "Pretty good," I think, and a little glow of pride comes to me. But on the other hand I am often distressed by the seeming emptiness and reproach myself for ineptitude, and think "How could I *ever* have done that?" Then I feel discouraged and wonder if that inner compulsion to bring a certain idea into being is not after all as much a curse as a blessing.

In any case, an early work is usually an impersonal thing to me, as if it had been done by another artist. I suppose it is much the same feeling as a parent might have who sees his child after an absence of years. For works of art, to the one who created them, change too — just as people change. This sounds rather silly, but it is true. Of course what happens is that the artist changes, not the hunk of wood to which he has given form. And yet, on the other hand, when I look at some of my earlier sculptures, not having seen them for years, I am amazed to find things there that I would swear were not there in the first place! Because, you see, the idea that brought the work into being — even after I had given it form and thus dismissed it — continued to grow in my mind, so that I see the carving as I would do it later, rather than the way it actually was done.

It is no good trying to manufacture ideas: they must come to the artist. But the artist's mind, like the mother's womb, must be receptive, ready to take in the germ of an idea. And it is this receptivity, or perhaps perception, which can be cultivated. How? By education, of course. And by education I do not necessarily mean the formal business of going to school, although that is a part of it. As any educator knows, each of us receives his education

32

mostly through himself, as the result of individual effort; classes, assignments, curricula, teachers, at best do no more than leaven our minds — at worst, they deaden them. Now the education of an artist is, to me, the most interesting of all, for it leads the individual into strange byways, into all kinds of strange and wonderful knowledge. It is the sort of education every human being should have, not just the artist among us. We too often forget in our search for wealth, power, physical possessions, that we are first of all human; it is so very easy, blinded by greed, to become sub-human or anti-human.

What would I suggest as an education for the artist? The first thing would be music: always and in great doses, music! Not necessarily the study of music or of any given instrument, though this would do no harm. It does not make much difference where one begins — whether with jazz, boogie-woogie, sentimental songs, or Tschaikovsky. Remember that it is also easy to educate one's self into a snob! But beginning anywhere in music, if the mind grows and the appreciative power with it, one comes to Beethoven and Bach and Mozart, and there is no point in forcing the process. Music is certainly the noblest creation of man and the best is none too good in the education of the creative person, who is too rare among us.

So let us place music at the top of the list as the greatest single generator of ideas; the greatest leavener of the mind. I studied the violin, organ, and piano for a total of some fifteen years, and those years — as art training — were not misspent. As long as I live I shall have music, particularly when I am at work. The chips fly faster, the mind is lubricated, everything is easier to do, carried as it were on great billows of sound.

Then literature, great literature. Read as much of it as you can. And here is a word for parents: don't be afraid to let your children read anything, even though you may consider some of the ideas shocking for one so young. I read everything I could lay my hands on as a child, protected by my mother's ignorance in many cases — I can still see her cocking an eye at me when she found me buried in what seemed to be an unusually interesting book! Ideas have never hurt anybody, and the bigger the ideas, the better. The youngster, the immature of mind, will be a nuisance, but that's

to be expected. When he begins to spout Freud and Marx and Veblen at you, don't be frightened or shocked; spout right back at him. For you, too, should be familiar with books, ideas. Read as much as you can from the minute you are able to read until you are so old you can't see the page. If nothing else, it will give you something to talk about and there's nothing like an enlightened exchange of information: I am not saying exchange of ideas, for they are so rare that we don't find many original ones entering into conversation.

And nature, as an educator, is the best! I prescribe great doses of it, whatever your age. You should browse, go into the woods, wade in the streams, pick up stones; taste, smell, hear, see, feel. Nature is the best developer of what we call "taste," for nature is never vulgar. She is grandiose to a point that would be vulgar in a human creature, yet is never vulgar herself. She is wasteful, greedy, lustful, inconsiderate, destructive, silly, noble, grand, sincere, playful — nature is everything that man is and then some more. She is a good playfellow for man, a good generator of ideas.

Then, have contact with materials of all kinds: natural materials especially — earth, rock, wood. Make with these, create! Learn to know the texture of smooth, polished wood and the texture of old stumps whose edges have rotted away; learn the difference in rocks — the glint of granite, quartz, the crumbling quality of sandstone, the smoothness of a boulder rubbed by the wind, the rain.

Ideas will come. Perhaps not ideas always for the artist's use, but at least ideas for a human being. And no matter what you are, whether doctor, merchant, lawyer, chief, your life will be richer.

Now to get back to the subject. Suppose you do have an idea for sculpture; you see a figure in your mind and feel it is ready to be committed to a material. Which material? Suppose it is the homely figure of a workman; specifically, a farmer. Obviously this is most suited to wood. But which wood? The choice would depend upon what the figure has to say: tiredness, energy, youth, age, kindness, humbleness, it must be a simple statement. One of these is enough, though in portraying one thing you

probably will portray many others as a luxury for the beholder. And he will bring to his looking whatever capacity he has to understand. All you can do for him is to state the thing as simply and as clearly as possible. In your sculpture you are talking to people, saying something to them; your sculpture is your alphabet, your grammar — one might call it a human alphabet. As you know, the best way to say anything, the surest way to be understood, is to speak as simply as you can. And the same is true in sculpture — in any art. Speak simply so that you may be easily understood. For you are, as it were, writing a primer of humanity.

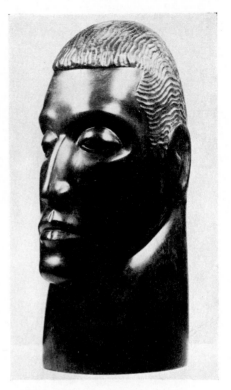

Plate 13. Athlete's Head. Ebony, 1941. 15 inches.

In making your sculpture, you must decide the material, the kind of wood. This choice itself is a subtle part of your statement. Use oak if rugged strength is to be shown or the gnarled hands of the aged. Walnut if a certain animal grace is to be depicted. Cherry if the color is to play a part in showing the glow of health, the inner warmth. Pear, if minute detail is necessary and the color is not too important. Apple, should you wish to work in detail and want strongly marked grain for accent.

After long working in many woods you learn which wood is best suited to your purpose. Let us look at some examples of my sculpture and see how good or bad my choice has been.

The two carvings I have made of John Brown, Plates 1 and 4, are in oak, a wood that speaks of the toughness — the moral fiber of the man.

The Athlete's Head, Plate 13, is in ebony, highly polished, to depict a

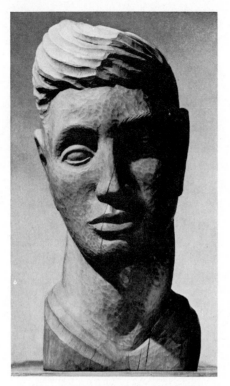

Plate 14. American Youth. Pear, 1943. 17½ inches.

certain kind of exotic creature, for we have often made our athletes into exotics instead of human beings. There is pride in strength here, but pride gone a little perverse; the narrow and pointed, almost phallic, head; the too carefully brushed hair; the sensual lips and eyes of a man whose body has been developed at the expense of his mind, so that he has become a suave, polished animal with the beauty of a horse or a bull rather than the beauty of a man.

Plate 14, American Youth: here is the beauty of a man, not fully grown to manhood, but the promise is distinctly there. He too has his sensuality, but it is that of a good, well-rounded man; in his face one does not see what one sees in the face of The Athlete. Here is a wistfulness, a plea for understanding of youth, asking only that he be allowed to live his life; to marry and beget children; to have his job and do it well; to live at peace with the youth of other lands. Compare these two heads and see how each says a different thing. Can you imagine the athlete married with a happy family around him? Can you imagine him being tender, having understanding? No, he is an exotic, an orchid. And he is made in ebony, a rare and exotic wood, unnaturally black. Whereas the American Youth is in pear: a wood that bespeaks grace in the tree itself, its fragrant blossoms, the lilt of the trunk and branches. And as a carving wood, though it is hard and brittle, it lends itself to the carving of objects possessed of spiritual as well as animal grace.

The Boogie-Woogie Boys, Plate 15, is in cherry, which may seem a

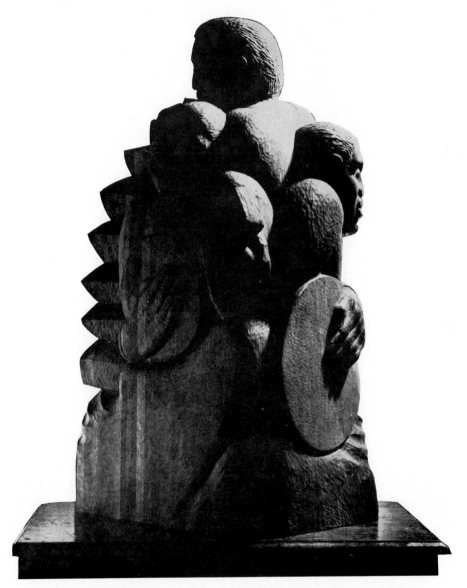

Plate 15. Boogie-Woogie Boys. Laminated cherry, 1942. 36 inches.

strange choice. I wanted a certain warmth, a certain inner fire like the insistent, rhythmic beat of the bass. I know that the piano is the instrument of boogie-woogie, but I did not want it in the sculpture: in any case, I feel sure that any of these boys could drop his accordion, drum, or banjo and turn to the piano! What I particularly wanted to put into the sculpture was the feeling of these jazz boys, playing on hour after hour — very tired, yet going on, half asleep. I wanted the feeling of the smoke-filled room and the boys continuing to play, their minds elsewhere.

Goin' Home, Plate 16, is in oak. Let me tell you a little story about her. I had a very specific idea in mind when I made this sculpture, but did not give her the specific title then because I felt that this woman pertained to something so local that not many people would understand. When she was first exhibited in New York, an acquaintance of mine — one of those sophisticated, rather brittle New York business girls, or so I had always considered her — came in. This was the first figure to catch her eye. "Good heavens!" she exclaimed, stopping in front of the sculpture, "you've done an old coal picker!" That was, of course, the idea that I had had in mind and Coal Picker was the right title. As a child, I used to see these old women walking along the railroad tracks and picking up pieces of coal that had fallen from the coal cars as they rolled by. Naturally it would have been easier to stay at home on a cold day and have a man deliver a load of coal, but these women were too poor to buy coal. So they walked along and occasionally, with a furtive glance around, stopped to pick up a piece of coal which they slipped into their sack; they did it casually, absent-mindedly, pretending that they were interested in something on the ground and the coal was incidental to that interest. After all they were engaged in a form of petty thievery and how did they know there was not a railroad detective hiding over there in a bush? They didn't realize that he would not bother to patrol a lonely stretch of open country. It's the sort of thing that makes one want to laugh and cry at the same time. The old women were stealing the coal out of necessity — a grim, tragic sight in a great wealthy country such as ours. But think how many times you have heard parents say, "No matter what, my children are not going hungry." Well, here is our little old woman,

38

her sack full of coal; she has left railroad property and is walking along the public road. Try to get her coal away from her! She's going home to feed her kids.

What I am trying to say here, however haltingly, is that the choice of wood should be suited to the subject matter. And beyond that, what I say is this: I am an American; I know the people I carve, their histories, their proclivities, their weaknesses, strengths, habits, their grandeur and their baseness. In short, I know why they are human and I am trying to show them thus and to explain to you what they are and why. When they cross your path, you must and can understand them. In my sculpture I am trying to talk to you. If you do not understand what I am saying in the sculpture, part of the failure may be mine and part may be yours. It takes both of us to make a work of art do its job.

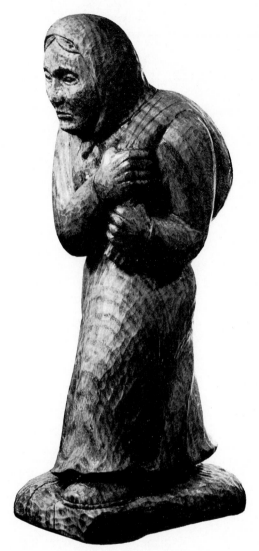

Plate 16. Goin' Home. Oak, 1940. 18½ inches.

Would it not be silly for me to try to tell you something about people whom I myself do not know? Imagine my attempting to portray Chinese dancers or Tibetan monks or Egyptian deities or the gods of any country other than my own! Yes, it seems to me that the artist does have a distinct obligation as far as his subject matter is concerned. He must "talk" about something that he absolutely understands.

39

If you are reading this with perception, you will realize that again and again I am saying, "The best sources of ideas and subject matter for an American artist are in his own background and culture." That is the clearest statement I can make of a conviction that with me is almost a religion.

Yet this conviction of mine — not that I claim sole ownership of it, since it is as old as art — arouses a great deal of indignation in many artists. It would seem that in stating it, one were trying to limit the artist to a very small area, were placing a straight-jacket on him. Which is a strange concept, considering that our own culture and background is as rich as that of any other artist in any other time or land. Certainly the Bible and all that it contains is a part of our culture and this alone embraces a universe of ideas. Then there is our own time with its jazz makers, night-clubs, road houses, hot-dog stands, filling stations, our great co-educational institutions; hoe-downs, quilting bees, moonshine whiskey, mountaineers, cowboys, farmers, mill workers, baby sitters, miners! Why attempt to list the thousands of things that are either as American as corn-on-the-cob or else so changed — as in the case of a country hoe-down — from their old country counterparts as to be almost new things. We have our own folklore, legends, tall tales, customs, regional differences, dialects, beliefs: what a rich country!

And yet how often one meets a young man, bright out of one of our great universities, who seems to scorn his heritage and speak with a quickening of the voice and mind only when talking of Chaucer or the Renaissance or the Greeks or some work of art or folk tale of a remote land. On mention of some quite homely festival or custom of the American hinterland, a silence falls. One listens to his praise of some minor but esoteric European poet for a time, then mentions one of our own minor but indigenous poets and he withers you with his contempt. Whitman was a muddlehead; John Brown was an old fool; Carrie Nation — she smashed windows, was a prohibitionist, a narrow-minded old hag! What is behind this attitude? Can it be that the boys are ashamed of their parents? Yet, though it is a hard pill for the professional esthete and the super-refined to swallow, we all came from the same people, and it is only by sincerity, by "belonging" where we belong, by being what we are, that we can produce art.

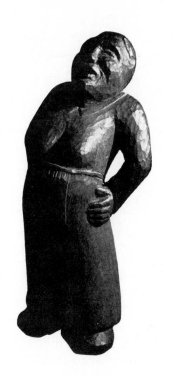

Tools
AND THEIR CARE

FOR AN ARTIST, space and the luxury of good things are as important as the tools of the trade. This is difficult to explain to the layman who argues that it does not make much difference where one works, since work certainly is hateful to all. The difference lies in the fact that the artist loves his work; is happy, really happy, only when he is at work. And if art is a necessity for human beings, then pleasant surroundings are necessary for the artist. It does not follow that all artists do have those pleasant surroundings. In reality, for financial reasons, most artists are forced to work in extremely unpleasant and crowded environments. Yet, as Carl Milles said to me once, an artist *should* be surrounded by beautiful things. Fortunately, beauty for an artist is often found in quite simple and inexpensive objects; the branch of a tree, a bunch of flowers, a piece of cloth, an old piece of furniture retrieved from an attic. Space is the first requirement, and given space, the artist will make his own environment. It may appear to the casual visitor that the studio is a terrific clutter of junk, but it is always junk which for one reason or another appeals to the artist.

41

So, in giving specifications for a sculptor's studio, I say, "Get as much space as you can; equip the room with the minimum of tools, then just let yourself go!" It will soon become your room, your sanctuary.

I know one painter who has his studio in a small bedroom. When you enter the door your eye is assaulted by a myriad of objects. There is not a square inch of the floor and walls that does not hold something: bits of grass, moss, rocks, branches of trees, decayed wood, skeletons, shells, feathers, pictures clipped from papers, books, magazines; paints, brushes, furniture of all kinds; hunks of clay, canvases stacked upon canvases, pictures in all stages from the sketch to the last varnishing, pictures piled on top of everything and precariously balanced so that occasionally there is a crash and down come several more things to the already cluttered floor. "Leave it alone," he says, "that's all right," as if the very falling is a part of his crazy plan! When one moves, he does so at his own peril, his ankles knocked by projecting corners of frames, benches, furniture. And yet the room is alive, charged with the man's personality, and I can understand why he paints best right there where everything is so obviously in the way. Beautiful surroundings? Well, beautiful to him.

Plate 17 shows my present studio in Minneapolis. The glass wall divides the space into two rooms, the one in the foreground for work in wood and the farther one for work in stone. Stone dust must be kept out of the wood-working area, hence the glass wall and the door which closes tightly. In the stone-working room is a sink, a necessity when one works with plaster or clay.

The wood sculptor needs a sturdy bench such as the one I have always used, shown in Plate 18. You will see that the bench is equipped with a heavy machine vice for holding the piece of wood in place. A vise is not indispensable, but it is almost so. There are ways of securing wood with a hand screw through the bottom of the bench, but I have never found this method very satisfactory. If you happen to be working on a large and heavy piece of wood, such as the log from which Eroica, Plate 3, was made, you need not secure it in any way. However, at the beginning you will probably be working on small pieces, when a vise seems indispensable.

42

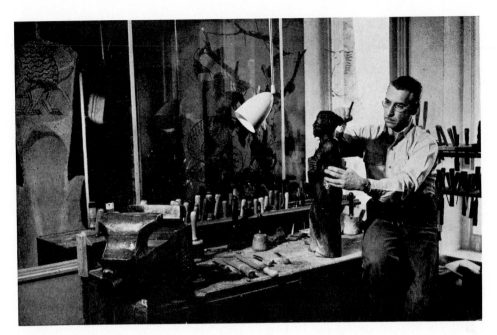

Plate 17. The studio.

Plate 18. The work bench.

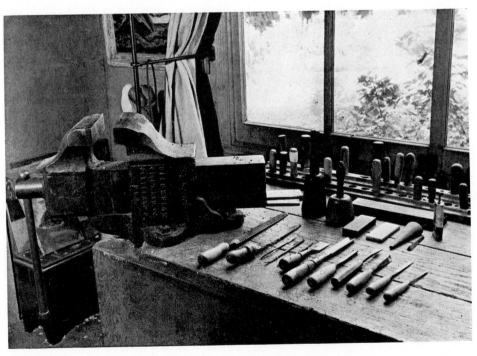

43

You can have the bench made by a local carpenter, or make it yourself, out of heavy oak—2 x 4 for the legs and braces, with a top 2 inches thick. You will notice that my bench is enclosed with plywood, which makes a good storage space, but this is not necessary. The cost is not prohibitive and such a bench is much better than any you can buy from supply houses.

The vise, however, is another matter. My vise cost about seventy dollars, which may seem to be a lot of money. But it is an unusually large vise, opening out wide enough to hold a block twelve inches in width. And though it may seem to be an extravagance, it has paid for itself many times over in the time it has saved me. You can get a smaller vise that will be adequate for about fifteen dollars. (See the Appendix for names of dealers who furnish supplies.) But when purchasing a vise, get one that will open out as far as possible; the wider it opens, the more useful it will be to you. There are regular wood carver's vises, but I have never been able to find them for sale in this country. Alan Durst, in his book on wood carvings (see the Appendix), shows a picture of the vise he uses, but it is expensive and would have to be purchased in England. It is true that the metal vise such as I use mars the wood, but if you leave a piece at the bottom for clamping, as explained in the next chapter, no harm is done to your work. If, for final polishing or for carving your signature, it is necessary to clamp the finished work in the vise, you can insert two pieces of soft wood between the piece of sculpture and the metal jaws of the vise. I always have on hand some small pieces of plywood of a suitable size for this purpose.

Then you must have a good mallet. Two are shown in Plate 18. Neither is expensive. I advise having the two shown: the larger one made of lignum vitae is for blocking out and heavy work, the smaller one made of hickory is for details (see the Appendix).

You will need the two wood rasps shown just next to the vise in Plate 18. The one at the extreme left is coarse-toothed, about 14 inches long; the one next to it is known as a bastard-toothed file and it may be the same size, 14 inches or shorter. Be sure to have these rasps fitted with handles— ten or fifteen cents extra. These you can buy at almost any hardware store.

44

Then you will need a pair of gloves with leather palms as explained in the following chapter.

Now for the cutting tools: get three or four carpenter's chisels — one is shown in Plate 18, the fifth object from the left. Don't be stingy. Get good ones, made of the best steel. Buck Brothers or Stanley chisels are my preference, with leather-tipped handles, but there are several other makes of chisels with good steel in them. You should have one 2 inches wide; one each of 1½ inches, 1 inch, and ½ inch. As a beginning you can get along with only the 1½ inch size and add the others later. But I repeat, get good chisels, made of the best steel obtainable. There is no economy in buying cheap tools.

As to gouges: again as a beginning I recommend regular carpenter's gouges. One is shown in Plate 18 next to the carpenter's chisel. Three of these are enough, sizes 1½ inches, ⅞ inch, and ½ inch. If you do not wish to buy all at once, start with the ⅞ inch one. However, if you are like me, once you begin carving you won't be able to resist tools. Let your pocketbook determine what you buy!

Perhaps I should say here that when I began carving I had only an old mallet, a wood rasp, one small gouge, and one 1½ inch chisel. With this simple equipment I turned out many pieces of sculpture. As a matter of fact, even now I quite often use no more than four or five tools in the execution of a piece of sculpture. And as outlined in the chapter on Rasps, you *can* do it with two tools only!

Now buy yourself some sharpening stones. A carborundum stone with two surfaces, one coarse, the other a bit finer. You do not need one as large as shown in Plate 18 (back of the mallets, extending to the oil can); the 5 x 2 inch size is large enough. Then an India stone, also with a coarse and a fine side, 5 x 2, as shown in Plate 18 to the right of the small mallet. And an Arkansas stone for the final honing, 5 x 2, as shown next to the India stone. You will notice in Plate 18 right next to the Arkansas stone two stones of odd shape. These are slip-stones and are used as explained later in this chapter. You will need the two shown: one for gouges, the other for V-shaped or parting tools. Then, to go with the stones, a small can of oil

such as the "3 in 1" shown: any household oil will do. If you are a purist, get Pike's Oil for sharpening stones.

With somewhat bated breath, you come to professional carver's tools. If you are like me when I first discovered their existence, you will go a little out of your mind! Even if you are a Rockefeller, get a good firm grip on your pocketbook — for the first month, anyway, until you *know* (as I knew practically the first day) that you have to carve to be happy. All you absolutely *need* is a small veiner for details. A No. 9, ⅛ inch will do. Write to one of the dealers shown in Appendix and ask for a catalog of carving tools; it will show shapes, numbers, and sizes of all tools. Don't make the mistake of getting tools too small: they make your work tight and fussy. Use a tool that seems even a bit too large rather than one too small. I often see students trying to block out a largish figure with a ⅜ inch tool when they should be using the largest one in their outfit, at least 1½ inch.

If you are not going to be satisfied with the veiner only, get yourself a No. 1, ¾ inch straight chisel. The fishtail chisel, fourth from the left in Plate 18, is best, for it enables one to work around corners and in small places. (See the Appendix.)

Here are other carving tools you should have: one No. 2 gouge, almost flat ½ inch; one skew or corner chisel ½ inch; one No. 6 gouge ½ inch; one No. 6 gouge 1 inch; one V, or parting, tool ½ or ¾ inch; one No. 8 gouge ¼ inch. Now you may find that this is far more than you can afford at first. My suggestion is that you let your family and friends know what you would like in the way of Christmas and birthday presents! But be sure that you tell them what and where to buy, else you may find yourself presented with a "set" of small tools suitable only for carving little boxes or for cutting linoleum blocks. These completely inadequate little "sets" of tools, all neatly packed in a wooden box, are what one is usually shown in art stores when one asks for wood carving tools.

Buy all of your carving tools with straight shanks. I recommend this for the reason that fancy curved shanks and fancy shapes generally, lead to fancy work. And as you will read later in this book, simplicity is the first and last of all the rules.

The above are minimum requirements more or less. You will need, and eventually accumulate, sandpaper, steel wool, nails, screws, hammers, saws, brace and bits, glue, and so on.

One thing more before we leave tools and working equipment: lighting. There is no light too good for the carver. I like my bench placed so that I can work with my back to the window or facing it—whichever is best suited to the work being done. Notice that the vise, Plate 18, is mounted on the corner of the bench; that enables me to work from either side. For night work, I have fluorescent lighting. One of the two tube fixtures, four feet long, is good. It should be suspended immediately over the vise, about four feet above it. There are two or three colors in fluorescent light, one of them a dead blue. I believe it is called "daylight," but I never in my life saw any daylight that color! There is a white one and a pinkish one. I use one each of the white and the pink. Even so, it is a cold light. If fluorescent light depresses you, as it does some people, get a large 150 or 200 watt bulb of the indirect lighting nature—it has a silver cap painted on the end—and mount it in a wide white reflector. I prefer the fluorescent light because it casts less shadow than the bulb. In any case, experiment with the lighting until you find what suits you best.

Just as important as having good tools is the care taken of them. A good cutting tool is a sacred thing. Somebody has said, "To work is to pray." Take it or leave it, tools are necessary for work, i.e., prayer, hence sacred. So do not handle tools as if they were old pieces of junk. Yet how many times have I, at somebody's urgent request—"Oh, I'll take the *best* care of them!"—lent a few tools and seen the borrower gather them up in his hands as if they were so many pieces of firewood. I am not a particularly fussy person, but that always draws from me, "In heaven's name, that's no way to handle tools!"

The cutting edges must not touch other metal or stone or anything harder than wood. When you are working do not let your tools lie helter-skelter, but place them on the bench, as in Plate 18. For carrying tools, have a heavy cloth case made with a compartment sewn in for each tool.

If you pause in your work to talk, don't fiddle idly with your tools. This is practically the only way I have ever cut myself; someone would be talking to me and, pausing in my work, I would twirl the tool in my hands and the razor-like edge striking flesh would remind me that this was no tea-party!

While talking don't poke at the bench with your tool. Most students do this until they learn better. I may stop to say something to a student, or he may ask me a question, and while we talk he pokes aimlessly at his bench with the sharp edge of his tool — sometimes, even, at the metal vise! I usually take the tool out of his hands, gently lay it down on the bench, and give him a look. If you must be doing something as you talk, make faces, rub your nose or your ear, or pull your hair out by the roots, but don't poke with the sharp edge of your tool!

Don't throw a tool on the bench; lay it down carefully. If you're slightly superstitious as I am, it might be a good thing at the beginning to learn that "a cutting edge is a sacred thing" and be governed accordingly.

When you are through work, put the tools back in their proper places in the rack, and be sure that there are proper places; no point in searching for a tool. Right here — at the risk of sounding bromidic — is the place to say, "A place for everything and everything in its place."

In short, treat tools as if they were rare things, handle them as if you never would have another.

A rack such as is shown in Plate 18 is good. You can very easily make this yourself. Bore holes of various sizes and cut slots at the sides of the holes to take care of the wider chisels. Make a shelf of soft wood under this rack so that if one of the tools should work loose from its handle which frequently happens, it will drop down on the shelf rather than on the floor. Also, some of the tools have larger cutting edges than handles and if the hole is large enough to admit the cutting edge, the handle will fall through. In this case, the edge of the tool can rest on the wooden shelf beneath without harm to it. You may be able to devise a better rack than the one shown. This one just happens to suit me: everything is right at hand and I know where each tool goes.

48

When you get new tools they are supposedly sharpened, ready for use. Actually, they are not. Let us assume that you have got the new chisels and gouges listed earlier in the chapter. Sharpen them all immediately and put them in their prepared places.

First, the stones: put a few drops of oil on the stone you are going to use. New carborundum and India stones absorb oil like blotters, but keep on adding oil as it disappears — that is, as you sharpen. The stone will become saturated after you have used it a few times. This reminds me of a rather annoying experience I once had when going to California. I took along a few chisels and stones thinking that I might do some carving while there. They were in a small kit, so I tucked it away in the top tray of my trunk. I rode across the desert in air-conditioned comfort; my trunk was in the non-air-conditioned baggage car. When I unpacked, I found that the oil in the stones had "rendered" out with the result that the contents of my trunk were soaked in the best sharpening stone oil! It was amazing how much oil had come out of those stones!

Keep the sharpening stones clean. If sawdust or dirt gets on the stone while sharpening, wipe the stone clean with a cloth and put on fresh oil. When you are through sharpening, wipe the stone clean, Don't leave oil standing on it to collect all sorts of dust and dirt. The stones should be kept just as neat as the other tools.

Start sharpening the chisels, since they are the easiest. The carpenter's chisel, beveled on one side, is held as shown in Plate 19. The tool is passed back and forth rapidly, being held as shown with the bevel firmly on the stone. You must learn the "feel" of the bevel, that is, place the chisel on the stone until it rests evenly on the bevel, then as you move the tool back and forth, be sure not to tip or rock it so that the bevel is first on the flat, then on one or other of the edges. A good flat bevel is very important; it is like a rudder guiding the tool when you cut. You should soon be able to pass the tool back and forth on the stone, the bevel as flat at the end of the stroke as it was at the beginning; it's a matter of keeping the wrists firm and not wobbling up and down. Don't keep at it until you've worn the metal up to the handle! I have a habit of counting the strokes: 1, up and back; 2,

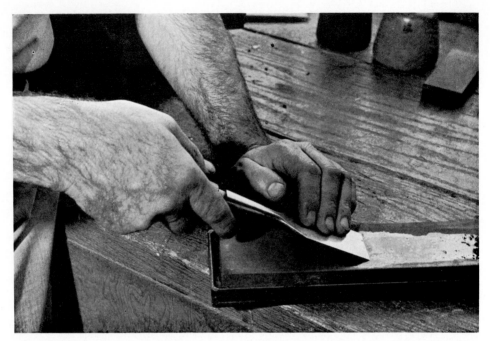

Plate 19. Sharpening a chisel.

Plate 20. Removing the burr from sharpened chisel.

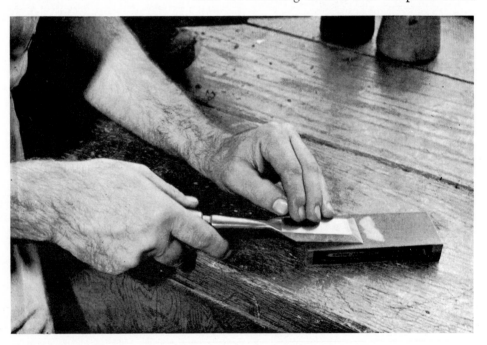

up and back; 3, up and back; and so on. A "sharpened, ready for use" chisel usually needs about seventy-five or a hundred strokes to remove the slight ridges that you will notice on the bevel of a new tool. This first sharpening should not be on the coarse side of the stone; use the smooth side of the India or carborundum.

When you have sharpened enough to remove those slight ridges that showed at the beginning, pass your finger across the back or unbeveled edge of the chisel and you will probably feel a slight burr. Remove this by turning the tool over (Plate 20) and taking two or three careful strokes *against* the edge, as if you were cutting. This should remove the burr. But it may not: burrs are sometimes stubborn and have a way of bending around the cutting edge. So, now run your finger across the beveled side and feel if the burr is there; if it is, then gently rub the beveled side against the edge in the cutting direction and feel on the opposite side to make sure that the burr is gone. If it is not, repeat the operation until it is. Be careful in rubbing on the unbeveled or flat side of the chisel as you may start a bevel there which will interfere when you use the tool. One way to avoid this is to hold the chisel very flat to the stone, as shown in Plate 20.

Now try the chisel on a piece of very soft wood; white pine is what I use. If, like a razor cut, the cut is smooth with no "pull" to it, then the tool is sharp. If there *is* a pull, or if small grooves show up in the cut, indicating nicks still in the tool, then sharpen it more until you can cut cleanly across the grain of the pine.

Then finally, hone the blade on the Arkansas stone in the same way that you sharpened it on the India stone. This takes just about the same number of strokes. When you are through, the bevel should be smooth and burnished. If it is a hand tool, that is one not to be struck with the mallet but rather pushed with the hands, then strop the blade on leather. A really well-sharpened hand tool should glow like polished silver.

Sharpen all the chisels in this way. If you have a fishtail chisel, you will see that it is beveled on both sides, so you sharpen both sides as above, *except* it is a very good idea to take the same number of strokes on each side, otherwise one bevel will be stronger than the other. This is how I happened

51

to get the habit of counting the strokes when sharpening: the fishtails, the skews, and the V's must be the same on each side, hence the obvious way for me to sharpen them equally was to count strokes.

If you have a bad nick in a tool, I advise having the tool reground by someone whose business it is to do this sort of work. (See the Appendix for the name of the firm that grinds tools for me.) You can try it yourself. Perhaps you have the knack. When I have to regrind a tool, I prefer to use an old-fashioned grindstone with water running on it. The faster cutting emery wheel can ruin a tool in an instant if the metal gets too hot — thus removing the temper. If you do use an emery wheel, have a can of water handy and dip the tool in it often to keep the metal from overheating. Small nicks can be removed by using first the coarse side of your carborundum stone, then the fine side, and finally honing. Or, if you prefer, use the India stone rather than the carborundum — it does not cut quite so fast and is preferable for tiny nicks.

Next sharpen the skews or corner chisels. These are sharpened in exactly the same way as the chisels, except you must be careful not to bear down on one tip any more than you do on the other for fear you will round it. I usually hold the skews so that the bevel passes across the stone at right angles as if it were a straight chisel.

The V gouges or parting tools are the very devil to sharpen. I have these done by an expert (see the Appendix), especially as they usually develop nicks in them by the time they need resharpening. Incidentally, these tools must be used carefully, because it is very easy to nick them: if you try to force them into a space too small, or cut too deeply with them, a piece as large as a quarter of an inch may break out of the cutting edge. Again, it might be a good idea for you to try your hand at sharpening a V as you may have a knack for it. Also you will find that you acquire much more respect and fondness for a tool that you have sharpened yourself! Treat the two sides of the V as separate chisels, sharpening them in the same way as you did the beveled carpenter's chisel. You will probably find, unless you're luckier than I, that there is a projecting tip where the two wings join together. Hold the tool as shown in Plate 21 and wear this tip down. I find

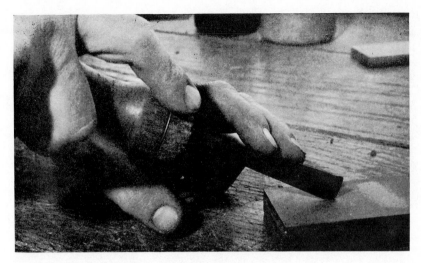

Plate 21. Proper angle at which V tool should be held to remove tip.

Plate 22. An old V and a new one: notice how rounded tip increases in size as tool is ground back toward shank.

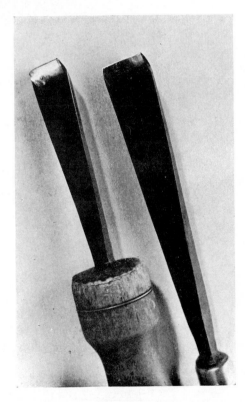

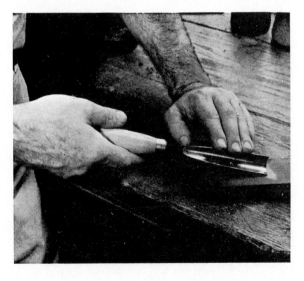

Plate 23. How to hold a gouge when sharpening.

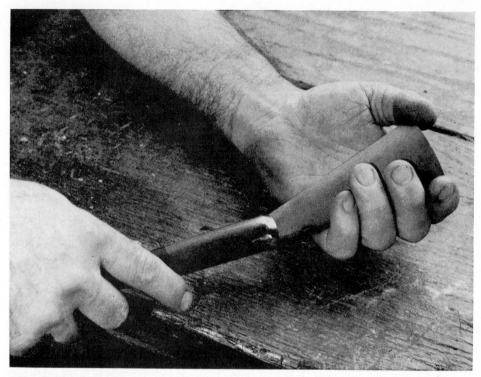

Plate 24. Removing burr from gouge with slip-stone.

that my V's work better if this bottom part is rounded as shown in Plate 22. Notice in the picture that the upper V is much more rounded than the lower one – this is because the upper one is an old tool and has been ground back to a place where the metal is fairly thick, whereas in the newer tool the rounded tip is not so pronounced because the metal is thinner.

When you have sharpened the outside of the wings and the tip has been removed, then you should take a few careful strokes inside with a stone of the proper V shape to remove any burr which may have developed. This is the smallest stone at the extreme right in Plate 18.

The gouges are all sharpened in the same way, holding them as shown in Plate 23. But do not pass the gouge up and down the stone as you did the chisel. Instead, rock it from side to side. This requires more dexterity than the sharpening of flat tools, as it is easier to get off the bevel. Also it is not easy to maintain the same pressure throughout the movement. This you

54

must learn by practice. Give the gouge a full half or three-quarters roll, the edges passing over the stone with the same pressure and at the same angle as the middle part. First, sharpen on the carborundum or India stone, just as with the chisels, then on the Arkansas; in the same way test for sharpness on a piece of soft wood; then remove any burr with a slip-stone. This is shown in Plate 24. Remember not to use the slip inside any more than is necessary to remove the burr, as the very slightest bevel here will interfere with cutting. In other words, your gouge will not know which direction it is supposed to go, equipped as it were with two rudders!

One last warning: I have seen students sharpening gouges by holding the bevel flat on the stone and rotating with a circular movement. Never do this. It makes flat places in the bevel. It can be done with chisels, but even for them I do not recommend the practice.

Probably after having read these descriptions for sharpening tools you think it sounds like a very complicated process, but if you follow directions carefully, you will soon get the "feel" of tools: sharpening is not nearly so complicated as it sounds. It is somewhat like swimming: once you get the knack, you will not forget it.

As a summary of this chapter: keep your tools in good sharp condition; take care of them; do not handle them thoughtlessly or carelessly; do not let greenhorns fiddle with them. In short, respect them.

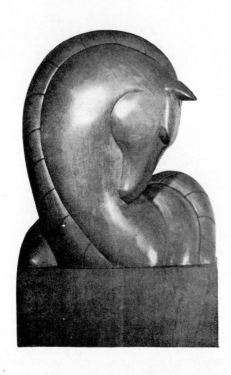

Rasps

FOR CARVING IN THE ROUND

THE RASP is one of the most neglected of carver's tools. Some carvers even discourage its use or say that it should be used with great discretion. The reason for this, no doubt, is that the rasp improperly used can produce sweet, rather insipid objects, which are enough to make any sculptor wince. If you study the illustrations in this chapter of some of my early work, as well as the work of other sculptors, you will see how exciting the use of a rasp can be — also how easy it is to be "carried away" with its possibilities unless you keep the limitations of the tool in mind and stop short of the spinelessness and insipidity that could result.

In my own experience I have found the rasps, together with rifflers and files, extremely valuable. Plate 25 shows two rifflers at the left, the bastard-toothed rasp next, and the rough-toothed rasp at the right. In carving very hard woods, such as ebony and lignum vitae, these tools are indispensable, since with almost the first stroke chisels and gouges become blunted or

nicked. These woods are almost as hard as stone; the grain in lignum vitae is so twisted that it is apt to snap off the cutting edge.

Perhaps I am especially fond of the rasp for the reason that it was one of the first tools I knew. As a child I had often seen blacksmiths filing away at horses' hoofs, making the surface even before applying the iron shoe. My cousin, at whose farm home I spent many summers as a child, was somewhat of a blacksmith. He had a forge and woodworking shop. I used to sneak into his shop when he was away, and use the tools. At that age I was forever "making something," little boats, airplanes, and so on. He found some of his chisels nicked and asked me if I had been using them. Of course I said "no," but he knew better. Thereafter he would allow me to play only with the rasp, which I could not hurt. Even if I did hurt it, it was an inexpensive tool, easily replaced. When I began sculpture in earnest, as told before, I found one of these old rasps, or "horse-shoeing" files as I still think of them, among the tools in the basement of my home. My first works were carved almost entirely with the rasp, and even now I often use only rasps, rifflers, and files in a carving. The Torso, Plate 26, is an example. Especially is this true when carving woods such as ebony, which, to my mind, demand a high finish to bring out their full richness.

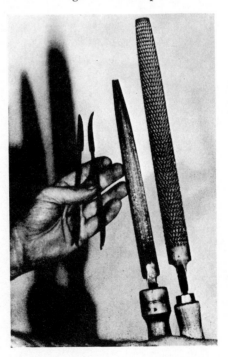

Plate 25. Riffler files, bastard and rough-toothed rasps.

If you compare Plate 26 with the detail of Big Boss, Plate 27, which was carved completely with cutting tools, chisels and gouges, you will see the difference the tool makes in the finished product. The Torso is suave and graceful, as if coaxed from the wood; Big Boss is rugged, dynamic, showing it was literally hacked out.

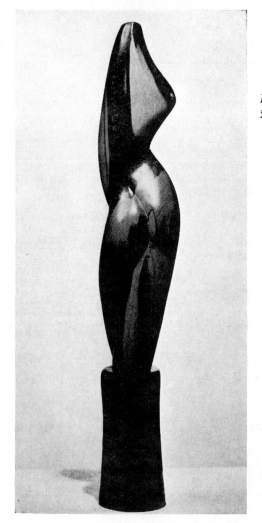

Plate 26. Torso. Snakewood, 1941.
21 inches with base.

Plate 27. Big Boss, detail.
Walnut, 1936.

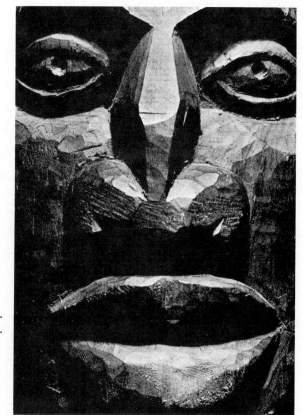

Plate 28. The design is drawn on the wood.

Plate 29. Using the round side of the rasp.

As I said before, some carvers discourage beginners in the use of the rasp, but to my mind it is the logical first tool. Surely the rasp, or its counterpart, a rough stone or abrasive, was the tool first used by primitive man in carving. Aside from such a specious argument, there is a very good practical reason for its being used first by the beginner: it is easier to "get around" a carving with the rasp. This getting around is one of the most difficult things for the beginner to grasp. Almost invariably, and it was very true in my case, the novice starts on a head and finds that he carves as if he were working on a bas relief. That is, he keeps the face flat and square: the front is square, the sides are square, and the back is square, the eyes are indented no more at the outer edges than they are at the inner; the chin, the nose, the brow, are all on the same plane.

To get away from this, I ask a student to begin with an abstract shape — in the case of a head, an egg-like shape. The shape is marked on the wood as in Plate 28. Plate 29 shows him beginning to cut with the rasp. Notice how the tool lends itself to long, sweeping strokes. The tool itself, in its

59

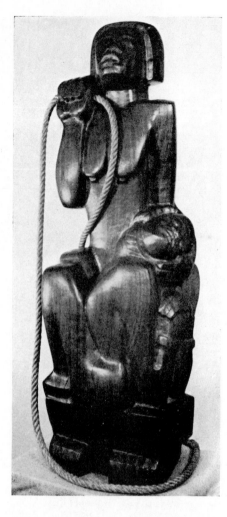

Plate 30. Aaron Goodelman's The Rope, showing retention of the rectangular shape. The wood is mahogany.

action on the material, seems somehow to determine the form of the finished object.

There is no conflict here in making a rounded shape; the square of the block is forgotten and one immediately begins to "feel" the rounded shape underneath.

Later, when one becomes master of various tools and types of wood, he may wish to retain the square or rectangular shape of a block to gain a certain effect, as was the intent in Aaron Goodelman's The Rope, Plate 30. But at the beginning, it is best to master the rounded form, which is basically sculptural, whereas the square shape is basically more architectural.

As a first project, select a piece of wood that cuts easily, such as white pine, poplar, or basswood. This first piece of wood should not be too large — say 3 x 3 x 18 inches.

Make a simple oval or egg-shaped drawing the exact size of the surface of your block, that is, 3 x 18 inches. Be sure that you draw clear to the edges of the piece of wood, except at the bottom where you should reserve about three inches to use for clamping the wood in the vise. This clamping in the

vise I will discuss later. Often a beginner will make the mistake of not filling the space with his design. The drawing shown in Plate 28 is right.

Like most beginners, no doubt you are saying, "But I want to make something — not just a shape like that." Nearly every beginner wants to be a Michelangelo the first week! Don't worry that this first carving is abstract, without special meaning; it does have sculptural form. At first "what" you carve is not important. It *is* important that you learn what your tools can do. There is no reason to feel impatient since it will not take long to learn the use of the various tools. Further than this, if you can get nicely proportioned shapes out of the material, you will find that you are thinking in "shapes" rather than in the superficial or realistic surface-aspect of objects.

If at the beginning you try to carve a realistic figure, you are apt to fail, and even if you do have some measure of success, the sculpture will be clumsy and inept in detail — in short, by trying to get everything exactly "right" you may get it all wrong. Carving abstract shapes in wood is, to my mind, comparable to practicing scales on the piano. Even today, when I feel my sculpture is becoming too labored with detail, as a personal discipline I make an abstraction, using only the rasp. Plate 31, which I call Baroque Form, is an example.

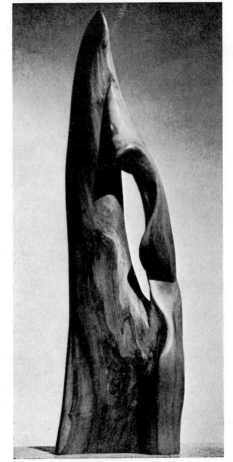

Plate 31. Baroque Form. Apple, 1943. 24 inches.

Secure your block of wood in a vise as shown in Plate 28. Now you can see why, in making the drawing, the three-inch piece was left at the bottom. While working, this free piece of wood is always available for clamping; later, if you wish, it can be sawed off. After you have worked for a time, you will find you are expert enough in your use of the vise, which has itself become a tool, that you can clamp your wood throughout the carving and in the end not need to cut off any of it. This was the case when I made Night Flower, Plate 32. I needed the whole piece of ebony to make the figure; the small carved base was made separately and attached with a long screw. Plate 33, Cat, has the clamping piece at the bottom left on for a base. In case you intend to leave this clamping piece for a base to the finished work, you must be careful in planning your proportion, not to have the base too heavy. There is no set or fast rule for determining the proportion; it is better to follow your own taste in the matter and let the size of the base be determined by the work itself. If you do not have "an eye" that will tell you when the proportion is right, there is not much that can be done for you! However, the probability is that without realizing it you do have a good eye for determining shapes, distances, and sizes. If this ability were not fairly general many millions of people could not learn quickly to operate airplanes, automobiles, and so on. Apropos of this thought, it might be said that people are speaking nonsense when they say they "never could get the proportions right." They would never admit that they could not walk through a furnished room — they are not aware that simple act requires ability to judge distances, spaces, and sizes.

To get back to the carving: put a leather-palmed glove on your left hand. You will need only the left-hand glove now, but save the other — a right-hand glove reversed *is* a left-hand glove! The glove is important, else you will — in your zeal — scrape the flesh off your hand.

Use the coarse-toothed rasp for the carving — the one on the right in Plate 25. Start with a long, even stroke of the rasp, using the flat side. Do not "ride" the tool; that is, do not bear down on it unduly. Just let it glide across the surface, pushing with the right hand, guiding with the left. Do not pull on the rasp with your left hand; your right hand can furnish all the

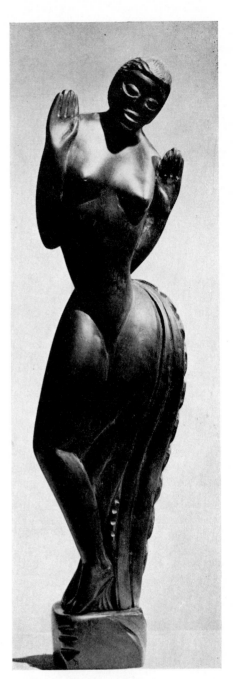

Plate 32. Night Flower. Figure carved without base. Ebony, 1941. 18 inches.

Plate 33. The Cat. Piece at bottom used for clamping is left on as a base for the sculpture. Mahogany, 1938. 20 inches.

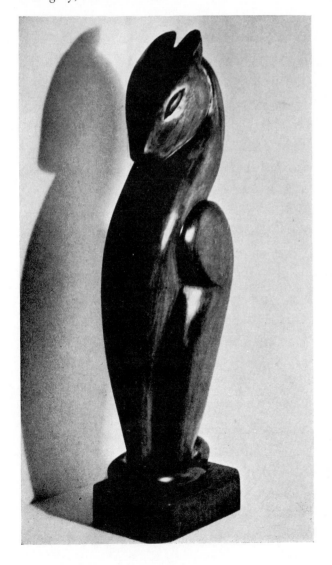

Plate 34. The basic shapes of the piece
beginning to emerge.

"push" needed. Furthermore, do not take your
left hand off the rasp, nor try to guide with the
right as well as push with it — you have no control
when you do this. Plate 29 shows the way the rasp
should *always* be held — both hands on it at once,
the right pushing, the left guiding.

Start at the top of the piece and work down.
When you have covered one side, turn the wood
in the vise and go to the next. Do not try to carry
any one part of the carving through to comple-
tion, but keep the whole thing going. Turn the
rasp on edge and use it as if it were a saw. Watch
how it makes sharp grooves in the wood. Carry
this movement up and around the ovals to define
the shapes. If you turn the rasp over on the rounded side, it will make
grooves such as those shown in Plate 29. You may want to include these
rounded grooves in your design.

Using these three cuts, the flat, the saw edge, and the rounded side, it
will not take long until you can see the basic shapes emerging as shown
in Plate 34.

You have, I hope, made a design of your own and not followed the one
shown here. If you have, you may wish to make variations in your design
at this juncture. Perhaps you will see some grain in the wood that interests
you. Don't be afraid to experiment; don't be a victim of a design you have

made; don't inflict your original design on the wood if you find that the grain is better adapted to a different design. Half the fun of making an abstraction is improvisation.

When you have finally arrived at a shape that pleases you, take the bastard-toothed rasp, second from the right in Plate 25, and go over the entire work carefully and slowly. You will see that this rasp erases the deeper tooth marks made by the coarse one.

When you have gone over the surface entirely with the bastard-toothed rasp, then take coarse sandpaper. No. 1 is coarse enough for the soft wood you are using. Rub the wood as smooth as you can, then take finer paper. Then finer still. Finish with a piece of 00 paper. If you desire an especially high finish, rub the piece with the finest grade of steel wool.

Turn to the chapter on Finishing and decide the type of finish you wish. Then after the proper finishing and final rubbing, your piece is done!

As a final inducement for you to learn first the use of the rasp, look with me at some sculpture which was, or could have been, executed entirely with rasps and riffler files. Rifflers are merely small, unusually shaped rasps.

Plate 35 shows an abstraction of a bird done by Bernice King, one of my students at the University of Minnesota, as her first project in wood sculpture.

Plates 36 and 37, Bird and Horse, were among my first dozen works. In these you can see variations of the forms made by the rasp, especially in the Horse. All three, as well as most of my early sculpture, were the result of making abstractions with the rasp just as I have outlined in this chapter. I make no claim of importance for any of these early works. They represent my beginning and as this method of working came naturally to me, I consider it the most logical approach.

If you are not familiar with sculpture, I would be willing to wager that you like these sleek, smooth early works of mine better than you do the more rugged sculpture shown elsewhere in the book! Because of this, even to this day, I have something of a struggle to keep on my course as a serious sculptor. People do like these rather facile, sleek sculptures for the obvious

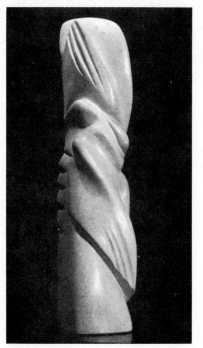

Plate 35. A first carving in wood using rasp only. Abstraction of a bird by Bernice King. Bass. 18 inches.

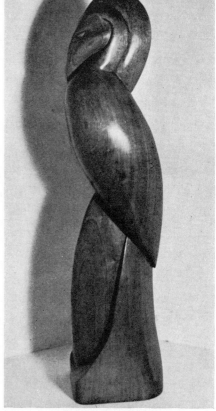

Plate 36. Bird. Mahogany, 1937. 15 inches.

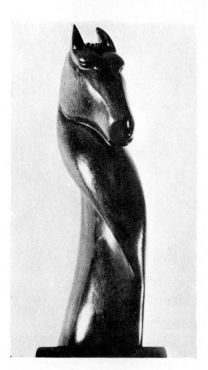

Plate 37. Horse — my early "meal ticket." Mahogany, 1936. 18 inches.

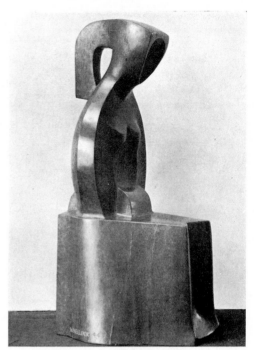

Plate 39. Resignation, by Warren Wheelock. Mahogany.

Plate 38. Salome, by C. Ludwig Brummé. Ebony.

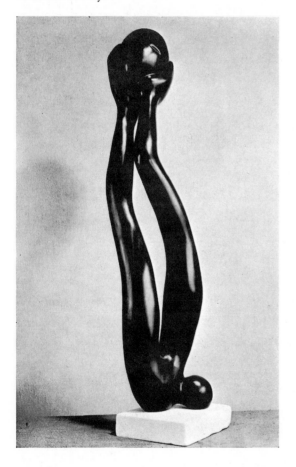

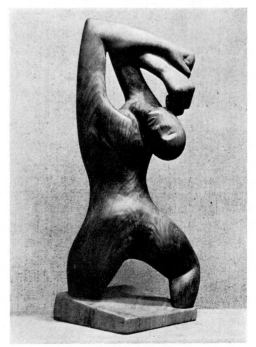

Plate 40. Defiance, by Blanche Dombek. Walnut.

reason that the surfaces are sensuously appealing — that is, they are at first. After seeing more sculpture and understanding it better, people generally, and you too, will gradually develop a preference for work of a more serious intent. It is the same with music. Most people who begin liking the music of Tschaikovsky, end up with a preference for the more rugged composers such as Beethoven or Brahms.

Even to this day prospective purchasers ask for these early, graceful pieces of my sculpture; for a time it seemed as if I would never be done carving the Horse. I jokingly called it my "meal ticket"! Everybody wanted one of the horses. I carved it six or seven times before finally refusing to do it again! And after you have finished reading this book and have looked at all the sculpture shown, I hope you will understand why.

Most of these early works were carved mainly with rasps and riffler files. Now let us look at more serious work by other sculptors which could have been executed with rasps and files, though I have no way of knowing that it was.

C. Ludwig Brummé's Salome in ebony, Plate 38, could have been done entirely with these simple tools. Notice the beautiful balance of the piece.

Warren Wheelock's brilliant abstractions are worth careful study. His Resignation, Plate 39, for instance, has all the feeling of the title without obvious descriptive detail.

Certainly Blanche Dombek in her Defiance, Plate 40, has to some extent allowed the material to dictate the design. Notice the interesting surface design which the grain makes across the larger three-dimensional design of the piece itself.

Now, having seen some of the possibilities of this simple tool, the rasp, I hope you are fired with an ambition to show what you can do.

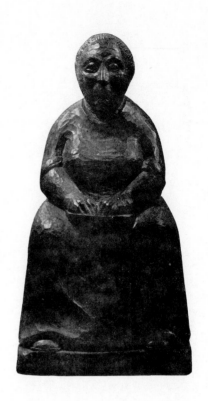

Carving
IN THE ROUND

I VERY rarely make a drawing for sculpture because the idea is usually so firmly in my mind that a drawing is superfluous. If it is possible for you to work this way, I believe you will find that your sculpture has more vitality than if you first commit your idea to paper or make a sketch in clay. By this latter method you are apt to find that you are slavishly copying the sketch or drawing. The relation of drawing to sculpture is a very subtle thing. In my own case I find that if I make a detailed drawing, the initial drive or urge to do the sculpture has lost its edge; as if, subconsciously, I felt the idea had already been expressed and hence further statement in another medium was redundant. Thus I prefer to make no real drawing at all. I do outline my idea in very general terms: a circle for the head, circles to indicate shoulder bones, knees, ovals for hands, feet, and so on, with connecting shafts for arms, legs, torso. It is my advice that you try to think sculpturally, that is, in three dimensions; visualize the thing in your mind in terms of volume, mass, form. However no two people are alike, and

69

Plate 41. Drawing, front view,
of Sky Gazer.

students often find it impossible to work without a preliminary drawing.
So proceed with the method which seems most natural to you.

When you have your idea in mind for a sculpture in the round, if you
think it advisable, go ahead and make drawings — all four sides if you
wish — though I advise making only the front, the back to be "followed
through" in a manner I shall describe.

Plate 41 shows a drawing for a block of wood 7 inches high, 10 inches
wide, and 3 inches thick. It is this block that we will proceed to carve in
the course of this chapter. The drawing is extremely simplified, but for me it
is an unusually detailed one. Make your drawing the exact size of the block
in which you are to carve. Don't make the drawing either larger or smaller
than the block; that is, if you should draw on a rectangle a figure supposed
to fit into a square such as is shown, naturally it is not going to fit the space.
It is amazing how often this mistake is made. A student will come to me
with a carefully drawn sketch of a figure that is supposed to be carved
from a tall narrow block. He will have made a drawing to fit a much wider
block; a drawing of a sculpture which obviously has the intent of showing
squatness! "But it will not fit," I say. "Oh, I'll make it fit." "But this is a

70

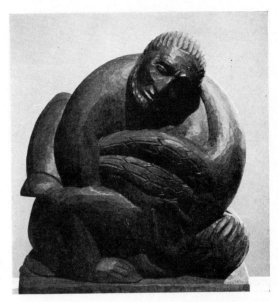

Plate 42. Jacob Wrestling with the Angel. Mahogany, 1941. 14½ inches.

drawing of a fat, roly-poly figure and cannot possibly be made in that tall block."

Students rarely seem to understand this!

The best way is to place the block of wood on a piece of paper and draw around the edge. That way you can be sure your drawing will fit.

Also, make your drawing fill as much of the space as possible. Forget that you are making a drawing on paper and think of the block of wood which is to receive the figure. In other words, though you are forced to work in two dimensions in drawing on the paper, think of the figure in three dimensions. Compare the drawing, Plate 41, with the finished work, Plate 59, and you will see the difference between the two-dimensional drawing and the figure carved in three dimensions. It is this difference which you must keep in mind when making your preliminary drawing.

Again let me remind you, *draw right to the edges of the block.* If you design the figure properly, you do not need to make openings between arms and torso, legs, etc. Avoid openings, for in most cases they are a distraction to the eye and lead to such monstrosities as the Laocoön group. Compare this group with Jacob Wrestling with the Angel, Plate 42. There is just as

71

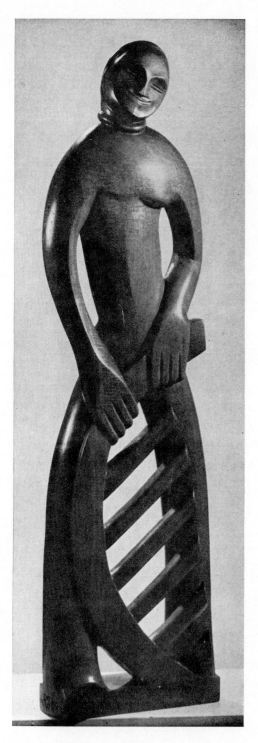

Plate 43. Man with a Rake.
Mahogany, 1940. 44 inches.

much action in the latter and as sculpture, it is better than the Laocoön —not so famous, I assure you, but it does hang together. To my mind, the Laocoön is better literature than it is sculpture.

Sometimes it is impossible to design a piece of sculpture so that openings do not occur. But as a general rule, especially in your earlier works, avoid them. Later you may wish to experiment with solids and openings, that is, positive and negative volumes or shapes. But my advice is first to solve the difficult problem of a design which has no openings through the body of the work. Toward the end of this chapter you will find photographs of sculpture, mostly abstract in nature, in which openings are used. In Man with a Rake, Plate 43, the open spaces were made deliberately, since this carving was not intended to be in wood. I hasten to add, before you think the last statement is that of a madman, that Man with a Rake is one of a pair that I intended to have cast in bronze as gateposts. The openwork, in metal, against the sky, would be more effective than if the figure had no open spaces.

Returning to your drawing, when you have it completed place it on the block of wood with double-faced carbon paper between the wood and the drawing. If you do not have double-faced carbon, then use two sheets of carbon, back to back, which will work in the same way — that is, when you trace your drawing the lines will appear not only on the wood but on the back of your original drawing as well. Now be sure that the edges of your drawing match exactly the edges of the block. Then use thumbtacks to fasten the drawing and the carbon to the wood, holding them firmly in place. Don't try to hold the drawing with one hand while you trace with the other, because one hand is bound to slip. For tracing, a blunt pencil is better than a sharp one. In fact, you don't need a pencil at all — you can use the end of a brush handle or any semi-sharp instrument at hand. When you have gone over every line of the carving, being careful that you miss none, remove the drawing from the block. When you turn the drawing over you will see that there on the other side you have in reverse the lines of your drawing. This, of course, is the reason for using double-faced carbon paper.

Now turn your block over, and put the carbon paper on it. Then lay this newly acquired reverse side of your drawing in place and secure it with thumbtacks. Now you are ready to trace this reverse drawing on the back of the block. Before doing this, visualize in the finished sculpture which forms will not show at the back and draw in the forms which *will*, that is, shoulders, buttocks, and in this case the hand at the right, Plate 44. If in both your front and back tracings you have been careful to match the drawing with the edges of the block, you should now be able to cut through the wood without danger of removing a hand, foot, or whatever — which might easily happen had you traced the drawing only on the front of the block.

Plates 45 and 46, front and back, show the drawings transferred to the block. As shown, it is a good idea to go over the carbon lines with white ink or chalk. Ink or water color is preferable to chalk because as you work it will not erase as easily.

Now you are ready to begin cutting. You need not worry yet about marring the wood in the vise, because most of the outside surface will even-

tually be removed. Take a saw and remove any large area, such as is shown in Plate 47 above the figure's left arm. Then, using a large carpenter's chisel, cut out the silhouette of the figure. Incidentally, use your chisel with the bevel side against the wood. In this way you can control the cut. If you use it the other way, on the flat side, you will find that your edge goes deeper and deeper and that you have no real control over the tool. However, sometimes it is necessary to cut with the wrong or flat side. Experiment with your chisel on a piece of scrap wood, using both the beveled and the flat sides. You will soon learn how much easier it is to control the cut when working with the beveled side down.

I usually start blocking in the head first, because in most cases it "decides" the figure. Also, and this is important, the head with its face usually is a focus for the emotional content of the finished sculpture. It is rather difficult to explain this, but if you read the chapter in Hemingway's *Death in the Afternoon* in which he discusses just what it is in a work of art or in a spectacle, that "sets the emotion going," you will understand what I mean. In my own work I always feel that if I can get the face and head right, the

Plate 44. The drawing as it appears in reverse.

Plate 45. The drawing, front, traced on block with white ink.

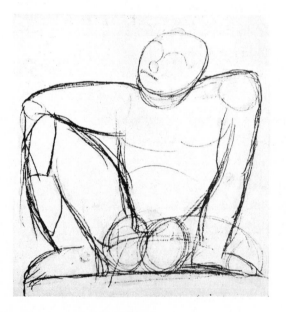

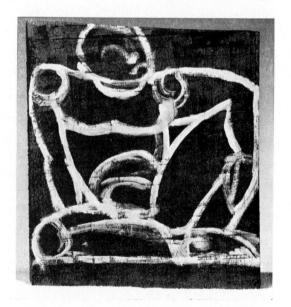

rest is comparatively easy. But don't finish the head now, just block it in, then do the same to the rest of the figure.

Now here is an important thing in sculpture: mark the direction of the spine, not only on the back, but on the front as well. You will see how I have done this in Plate 46. If you look closely you will see it again in black pencil markings in later illustrations of the sculpture in progress. Remember the spine runs up to the base of the skull. Now the spine can be curved in an S, or it can be shaped like a C, but it cannot be bent into an angle, although from the way I have seen heads placed on sculpture by beginners, it would seem that an entirely new kind of anatomy had been discovered! Mark the spine front and back and keep it marked; when you cut off the direction line, draw it on again.

Another thing to remember: if a figure is standing and you could drop a plumb from the pit of the neck, it would fall through the inside of the ankle of the foot supporting the weight. If the weight is evenly divided between the two feet, then the plumb would drop an equal distance between them. Try this and test the above rule. You will see that if you stand

Plate 46. The drawing, back, traced on block with white ink.

Plate 47. The silhouette cut out, using chisel shown.

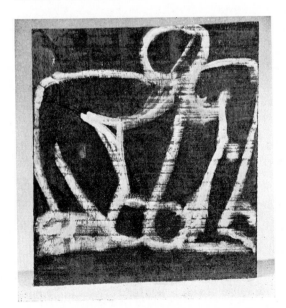

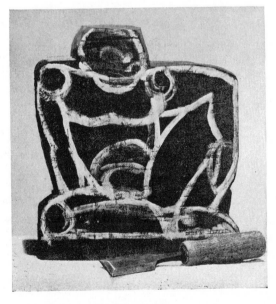

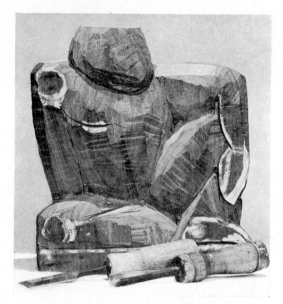

Plate 48. The figure blocked in, front. Chisel and V shown were the only tools used.

on one foot, no matter how you contort your body, the pit of the neck is exactly above the inside ankle of the supporting foot. This is a very simple thing, but if you remember it, you will not carve figures that lean forward or seem to be off balance. There is nothing more distressing than to see a figure that seems to be perpetually falling — unless that was the sculptor's intention.

Plate 48 shows the first actual carving on the piece. See what has happened once the cutting begins. The raised thigh at the right seems to be thicker than it did in the drawing; the width of the torso has increased; also the leg on the ground which in the drawing looked too thin, has now begun to take on thickness and size or rather, scale. This is why drawings are not much good unless you can visualize what will happen when you begin cutting: as the carving progresses, dimensions seem to increase because the new dimension of thickness is added.

The arm at the left of the picture has been cut back to make way for the knee. Notice also a change that I have made in the foot at the right. In the drawing it seemed to be flat on the ground, in carving I have curved it so that the toes will seem to grasp the edge of the base. Had it been left flat,

76

it would give the figure too static an appearance; now, gripping the edge, it takes on life and will contribute vitality to the entire piece. These are the little changes that one makes as one carves.

There is a very good trick that will help you as you carve: take the pose of the figure yourself. This is much better than to have someone else pose for you. Try to get into the same position as the figure you are carving and "feel" what comes where! Close your eyes and visualize the placement of arms, legs, hands, feet, the tilt of the head, weight of torso, and so on. Dancers tell me that this is very much a part of their training, this "feeling" of the movement. Any training that a sculptor can get in mental visualization is all to the good.

By this time you should have begun to get an idea of what you can do in wood. You will see that grain plays a great part in the actual cutting and that there are some things you can do and others that you cannot. Also, you can see that a figure must be distorted to get it inside the limiting space of your block. Have a friend take the pose of the figure and see how much the actual pose differs from the carving. There is so little relation that the actual model is of no use to you; in fact, it is a hindrance, as the figure seen cannot really be done in the wood. As a consequence, a rather distressing psychological hurdle is apt to be set up because you feel that you *should* be able to reproduce the pose of the model. Hence, try using the trick mentioned above of taking the pose yourself and mentally visualizing "what goes where."

So far in this demonstration I have used only two tools: a 1¾ inch carpenter's chisel and a V gouge or parting tool whose full width through many sharpenings has been lost. Originally it was one inch. This use of few but large tools at the beginning is important. Never use a ¼ inch tool if you can possibly use a ¾ or 1 inch. You will accomplish more and the work will be less tight and timid. I have sometimes seen professionals attack a large block of wood with a small gouge that should be used only for fine details. One time while visiting the studio of a well-known sculptress, who models more than she carves, I noticed in the corner a partially completed figure, half life-size, in mahogany, which is one of the easiest of woods to cut.

When I said something about the figure, she remarked, "Oh that. I've been working on it for nearly a year but just don't seem to get anywhere with it." And no wonder: she had been using a half-inch gouge! Timidity leads students into the false practice of using too small tools. A large tool well used, will not cut off too much and will give greater vigor to the work.

When cutting with a chisel, always make a "guard" cut before taking off a piece of wood. Let me explain a guard cut. Suppose you wish to take out the more-or-less V-shaped hunk of wood between the head and the shoulder in Plate 48. You should first cut straight in at the base of the head with a firm stroke of the mallet—not too far; just enough to guard against undercutting when you make the next stroke. Then cut up to it from the shoulder, going no deeper than you have cut with the guard stroke. The wood that you wish to remove will be freed and will come out neatly; the shallow resulting V will be clean. If you wish your V to be deeper, repeat the process, but always make a guard cut. This guard cut removes no wood, it merely prepares for the second stroke, which is made from an angle. Unless you follow this procedure, you will find that you make a cut with the chisel, then twist it in an effort to wrench the wood from the block and the result will be as ragged as bread torn from a loaf rather than sliced.

Perhaps you may ask, "What difference does it make as long as I take off the wood?" But think for a minute—imagine making each stroke in this way and afterwards twisting each piece of wood loose. Eventually your entire figure would become a mass of undercutting and when you arrive at the stage of finishing details, you would find the wood so chewed and mangled that it would be impossible ever to get a smooth surface. Plate 50 explains this better than I can with words. To show you what happens, at the lower left I have deliberately cut down from above without first making a guard cut; at the end of each stroke I twisted the chisel to tear the wood loose. If such a mangled surface developed at the edge of the head or foot or in some place requiring delicate carving, you would find many splintered places in the wood and it would be impossible to get a clean, solid surface without attacking your piece again and probably cutting back further than your design would allow.

78

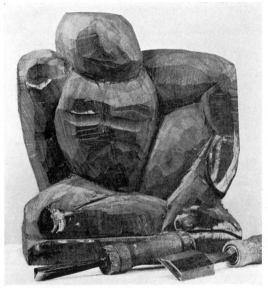

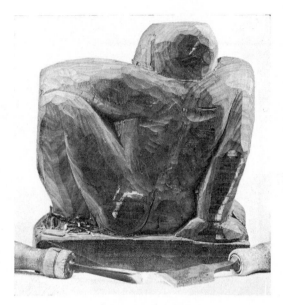

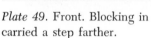

Plate 49. Front. Blocking in
carried a step farther.

Plate 50. The back beginning
to take shape.

Plate 49 shows the front of the piece blocked in still more than it was in Plate 48. The shoulder at the left is thrusting forward; the head is taking more shape; the thrust of the torso is more pronounced; the slant of the thigh at the right is accentuated. The arm on the right is too thick and must be cut down more. The leg resting on the ground looks hopelessly crippled and rather alarmingly as if there were not enough material to bring it into proper shape. In later stages we shall see what can be done. The overall pattern or design is all right; the cut from the knee of the ground leg up to the crotch, thence up the side of the torso and across to the elbow on the right makes an exciting zig-zag pattern; the areas of torso, legs, arms, head are sufficiently varied in size to give interest. Note that the largest area, that of the torso, is roughly framed by the masses of head, arms, legs.

Now to the back: Plate 50 shows that we have gone a good deal further here. The head is shaping up; the arms, legs, and back have begun to take on form. There are some problems here that should be pointed out: the thrust of the thigh resting on the ground must be made to "work"; the heel of the hand must be brought out properly to give the feeling of weight rest-

79

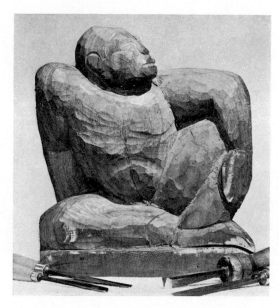

Plate 51. Compare with Plate 49
to see what has happened
to the head.

ing on it; the arm flung across the knee must rest there lightly and casually; the leg at the left must go forward to the knee but since there is not much thickness here — the block is only 3 inches thick as compared with the height of 7 inches and width of 10 inches — the modeling must be done carefully else the leg will look crippled. Notice that the grain of the wood is beginning to come out in interesting patterns. This could easily seduce you into abandoning your original idea, but as a carver you are too young to be led astray at this stage. Later, when you have learned more dexterity and skill, you can allow grain to lead you into new ideas and strange forms. In any case, you will find that in the end the grain almost always is kind and helps to accentuate the roundness or the length of forms.

From the first cut almost to completion there is no stage of a carving when you are not whistling in the dark to bolster your faith in the ultimate outcome. The drawing, as you can see by now, is a very frail chart upon which to steer a course. Like Columbus we are going forward as much by divination as by knowledge! But Plate 51 shows that we are on the right track. As said before, once the head is well set and the rough carving on it done, then I breathe easier. As you can see here, the head already carries the

intent of the entire work — that is, of a fairly primitive man sitting on the ground and gazing at the sky with some wonder. Our Sky Gazer is beginning to be that not only in title but in the entire posture and expression.

Let us begin with the head. It has been released from the rather amorphous block shown in Plate 49; the chin is properly lifted; the eyes look up; the jut of the jaw gives purpose to the head; the back of the jaw has the proper weight and strength. The ear, too, helps tremendously. It is now merely indicated, but its placement is right — that is, almost directly parallel with the nose and set a little more than half way back from the front of the head. The same principles are being carried out in carving this head as are outlined in more detail in the next chapter — that is, the nose first, then the mound of the mouth, and so on. However, the small head of this Sky Gazer will not be completed with as much detail, because it is only one part of a whole figure and too much attention to detail would detract from other parts and from the concept of the figure as a whole.

Let me confess that the neck had me worried before now. As I emphatically stated before, the head fits onto the spine and can be moved from side to side, but you must be sure that it is set on the spine properly. The pit of the neck must connect with the slight ridge down the front that parallels the direction of the spine at the back; and yet, in this figure up until now, there was little indication of how I might accomplish this. But when I began carving the head, it all became clear; once the chin and nose were put in, the position of the neck was immediately apparent. Another thing that worried me was the muscle that goes from the base of the ear down to the pit of the neck — in this particular figure, this muscle is important. It now begins to show and it will be simple later to give it prominence.

Perhaps this is as good an opportunity as any to say that I am not trying to teach you much about anatomy because my own knowledge of it has come by observation rather than from formal study. When I don't know "what goes where," I ask someone to pose for me, or else I look in a book. Several books are listed in the Appendix as reference; if you wish to memorize all the bones and muscles, it won't hurt a bit — besides, you can dazzle your friends! But don't get the idea that knowledge of anatomy will create

a work of art, for it will not—but it may help. Some of the dullest sculpture ever inflicted upon honest stone or wood has been so full of anatomical knowledge that it makes one's head ache. To my way of thinking, and I believe this is true of most contemporary sculptors, the material in which you are working is your first consideration—you are not carving flesh, and you are not trying to take over God's role, but rather you are explaining, making comments, giving your feelings, imparting knowledge about His work. The face of Barlach's Revenge, Plate 52, is infinitely more expressive than if he had carved an anatomically correct face, for here we find a certain regret, yet purposefulness. There is a quickness about the figure, a striking forward, that was achieved much more because of the artist's knowledge of design and especially knowledge of design in his chosen material, wood, than because of his knowledge of anatomy. One is tempted to

Plate 52. Revenge, by Ernst Barlach.

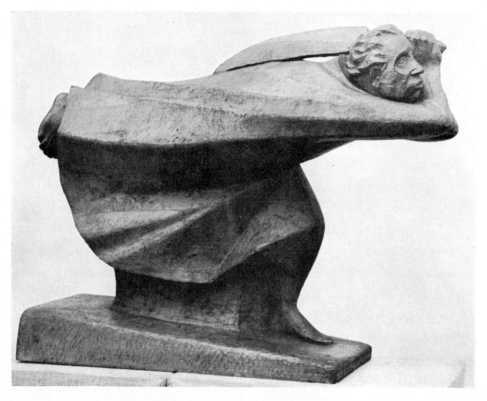

82

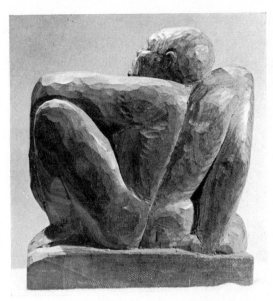

Plate 53. Notice physical tension
expressed in arm at right.

say that for an artist too much scientific knowledge is a bad thing. However there is more truth in saying that if the artist has a real message to express, no matter what his knowledge or lack of it, he will find the right way to say it.

Back to Plate 51 again: the forms are beginning to round out; as you can see, the arm at the upper right has been cut down so that it is in better proportion — for a time it looked as if the upper arm might be too long for the forearm, but by altering slightly the silhouette and by cutting the elbow in a little, the forearm has been lengthened and at the same time the upper arm shortened. The arms are still too bulbous and need a good deal more modeling but we shall come to that.

Now let us see what has happened to the back, particularly the arm at the right on which the weight rests, Plate 53. Aside from the physical tension expressed here — one feels that the bone might burst through the flesh at the shoulder — almost the entire emotion and idea of the piece is dramatized in this right side. Cover the right side with your hand and look only at the left. You see a more or less relaxed figure gazing at the sky. Now cover the left side up to the face so that you get the strong diagonal of the

83

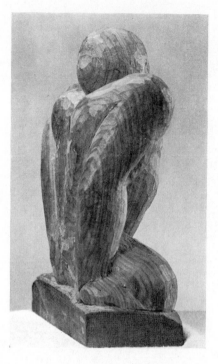

Plate 54. Study the relationship
of forms here, also the grain.

backbone, the thrust of the head in one direction
and the arm in the other. Here we begin to feel a
terror which is more than simple wonder; the fig-
ure is tense, poised ready to leap away from the
fearsome thing he sees in the sky. It is terror add-
ed to wonder. This is not the simpering lady hold-
ing up the lighting fixture in Aunt Minnie's front
hallway — the only sort of sculpture I ever saw
until I was practically a grown man! It is primitive
man, perhaps you and I, too, gazing at something
he does not understand, at something that arouses
his wonder and yet fills him with fear.

The detail of Plate 54 is worth study. I would never claim that this arm
is anatomically correct, but I do say it is right for what I want to say in the
sculpture. Study the design relationship of the round of the head, the
shoulder, the elbow, the back of the shoulder, the protruding rib arch and
the knee; your eye zig-zags from one point to the other — and it is this rapid
angular movement that gives excitement and tension.

Compare Plate 54 with Plate 55, de Creeft's Salammbo, the masses and
lines of which are softer and more gracious as befits the subject. Also com-
pare the grain of the wood in the Salammbo with the grain of the wood on
which we are working. The grain on the Salammbo follows the masses ten-
derly, rounding out the belly, the thighs, the breasts, whereas in the Sky
Gazer the grain charges from one direction to the other so that it accents
the thrust of the knee. The grain runs up across the shoulder; and along the
upper arm it is like flying buttresses helping to support the weight and
accentuating the buttress-like form of the entire arm.

The possibility of using the grain in this way is one reason why wood

84

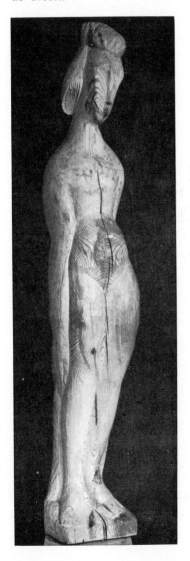

Plate 55. Salammbo, by José de Creeft.

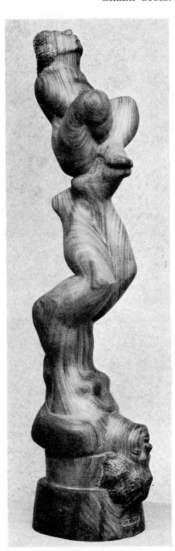

Plate 56. Tumblers, by Chaim Gross.

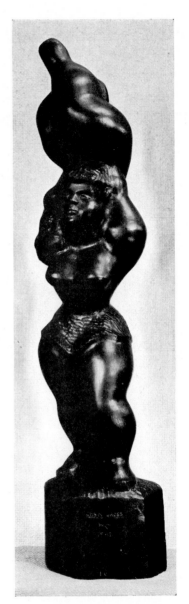

Plate 57. Acrobatic Dance, by Chaim Gross.

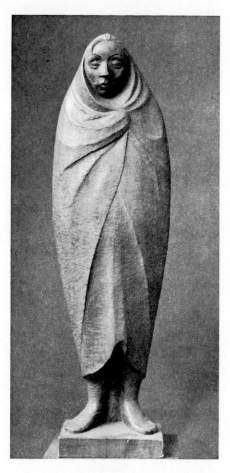

Plate 58. Peasant Girl, by
Ernst Barlach.

is so sympathetic to sculpture. Exploitation of the
grain can be overdone; in my Torso, Plate 26, it
comes perilously near. But look at Chaim Gross'
Tumblers, Plate 56, in lignum vitae, and see how
much the grain contributes to the movement and
to the modeling of the figures. An interesting com-
parison is with Gross' Acrobatic Dance, Plate 57,
carved in ebony, a wood which usually shows little
grain. In this latter piece, the agitated rhythm of
grain of the Tumblers would be out of place. In
other words, you must know the wood you are
working in and there is only one way to learn —
carve in as many woods as possible.

While we are on the subject of grain, let us
look at Plate 58, a good example of sculpture with
no grain showing. Peasant Girl was carved by Bar-
lach, whom I consider the greatest carver in wood in our time. Personally I
do not feel that the grain of a wood, certainly none of the more florid varie-
ties, would have helped here — it would have detracted. This figure is in oak,
which I believe is the wood most often used by Barlach. We shall have no
more works from this great sculptor; he died just as the war began. His
sculpture has been my greatest inspiration; I advise you to study it care-
fully. Examples of his work may be seen at the Bucholz and Weyhe Gal-
leries in New York; the Museum of Modern Art has two pieces; there is one
at the Art Institute in Chicago. On the whole, however, our museums have
neglected him, tending to patronize less rugged sculptors. A monograph,
listed in the Appendix, published in Germany before the Nazis reached full
power, contains many reproductions of his work.

86

In this illustration of the Peasant Girl it is the shape that counts mostly —a very simple oval shape of a girl who appears to be pregnant. There seems to be a womb-like quality to the whole figure—a feeling of gestation. The cloak is held about her protectingly; there is a thoughtful, indrawn look on the face. While making comparisons, see if you can find a reproduction of Brancusi's Bird in Flight; this is a swift, rising form befitting the subject, whereas Barlach's form—in general shape not unlike the Bird in Flight—is rooted firmly to the earth. Ten to one you are familiar with Bird in Flight but never before saw the Peasant Girl. Perhaps you never before heard of Barlach. It is a commentary on the artistic ignorance of our times that Brancusi's bird—which, although sleek and pleasing in design, says very little—is known to all; whereas Barlach's sculpture, infinitely richer in what it says as well as being sculpturally quite as interesting, is practically unknown.

Plates 59 and 60 show the completed Sky Gazer. The face has been left rather blocky, as have also the hands and feet. Notice the hair, the simple way in which it was done. A gouge was merely twisted back and forth with

Plate 59. The Sky Gazer completed, front view. Walnut, 1946. 10 inches.

Plate 60. Back view of the completed Sky Gazer.

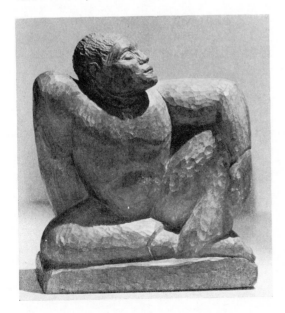

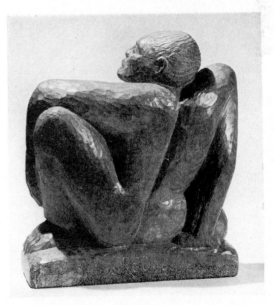

an irregular rocking motion as it was pushed through the wood. The tool marks have been left. I like this rough tool-mark finish best on figures of this sort. A smooth, rubbed finish such as given to Man with a Rake, Plate 43, would take some of the strength away from this figure.

Finally, to pull it together, a coat of wax was put over the whole figure. You will find that the marks made by tools cutting across and with the grain vary somewhat in the way they catch the light, and wax helps to make them seem the same. Then the Sky Gazer was rubbed well with a soft cloth and our demonstration is finished.

Now compare this finished figure with the beginning as shown in Plates 41 and 44. You will see how far we have come. And yet in the lines of the original drawings you can see the possibilities of the completed sculpture. What was a design of lines on flat paper has been translated into rounded, sculptural form. That's all there is to it!

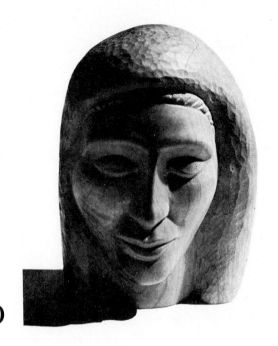

Carving A HEAD

SINCE DIGRESSION, as you have long since discovered, is not only a weakness of mine but almost a disease, I would like to tell a story about the log we are going to use in making the carving of a head.

Some ten years ago a university student, James Johnson, worked for me, helping with the heavier jobs around the studio. Jim was an outsize man — over six feet — and an athlete at Ohio University. His home was in Cleveland and occasionally he would bring promising young athletes down to Athens to help them enter the university. One vacation he arrived in town quite late and I had gone to bed. He asked my wife if he and a friend might stay overnight. I had slept soundly and heard nobody moving about so that the next morning as I passed through the hallway, I glanced at the end room and saw a stranger — as big as Jim — practicing handstands. "What's going on here?" I asked. Jim stuck his head up out of the bed-clothes and called to me, "Fellow I want you to meet. Max Garfinkle."

A year or so later Max entered the university and was a consistent visitor at my studio. Aside from being an athlete, he was an "A" student, and more than that, he was unusually intelligent: one of the nicest fellows

89

one could know, gentle, kind, sensible, and at the same time a man of strong convictions and beliefs. He was very fond of abstract discussion of politics, religion, philosophy, and many were the evenings we spent around the studio fire discussing everything under the sun. He seemed to enjoy those quiet talks and I know that I did.

Then the war came along, and Max, one of the gentlest people I have ever known, found himself about to be drafted. He and I had discussed war many times; he did not believe in it, did not think that the ills brought about by it were offset by the gains, although he was not what one would call a pacifist. If it were a good fight, in a good cause, he was in there pitching.

As long as I live I will remember his graduation day. He came to my studio in the evening and found me alone. "I want to spend my last evening here," he said, looking about the room as if wishing to memorize every detail.

"Fine," I said.

"Do you mind not working tonight?" he asked. "Just sit and talk?"

There was no fire in the fireplace, but we sat down before it as we had on so many other evenings. He was very quiet, spoke in an even, gentle tone. "I'm going to enlist tomorrow," he said, "in the Navy." I asked him why he did not wait until he was drafted and he answered that he preferred to be an enlisted man. Then I suggested that he try for a commission, since he had special abilities which would be useful.

"No," he said, "that wouldn't be right for me. Gosh, how I hate it!" He was quiet a moment, then went on: "You know how hard I have worked to get an education." He had worked in a junk yard to make money to enter the university; he always had a part-time job while in school. It never had been easy for him — even necessary clothing was a luxury. For instance, all during his years at the university he went out for sports so that he might have a warm sweater to wear, and he practically lived in that sweater, fall, winter, and spring. On this evening of his graduation he was wearing the sweater that was his uniform; he had had no new suit.

"I had to wait two years before coming to college so that I could save

90

enough money to get started," he went on. "Now I'm through, but I want to go on and get my master's and Ph.D. — when and if." He smiled wryly. "And all my life I've built up my body, as if it were a temple. So now I am going into the war and will use my brain and body for something I don't believe in. But I'm a Jew; I've got relatives over there now. I don't see how I can do anything else."

He talked as if he did not expect to come back; the whole room seemed charged with that feeling.

After a time he asked, "Would you play that music I like so much? I'd like to hear it before I go."

"Sure," I said, and put on the first record of the Dvorák B Minor Concerto.

He said nothing as the heroic and lordly music flooded the room. Little was said until the last record and then he said, almost as if speaking to himself, "It's like the end of the world." Then he got up, grinned, held out his hand. "So-long," he said. I didn't answer, just shook his hand.

Then letters began to arrive from him. In no time at all he was an ensign, then a lieutenant (jg) — how scrupulously he always put the (jg) on his envelopes! Others seemed not to mind if one thought them full lieutenants!

Then came a V-mail letter from the Pacific asking, "Is there any particular kind of wood that I might get for you? How about some teak?" I wrote back that there was nothing in the world that would please me more than a small log of teak. About two months later I received the following letter:

July 11th, 1944

Dear John:

If you were to know what wild goose chases I've been on and what adventures have befallen me since your most innocent request for teak!

At the risk of boring you I'll relate some of them. One bright sunny afternoon (always an ominous sign in the tropics) I set off into the jungles with some of the men in search of teakwood. We were working our way down the side of a partially cleared hill when we went into a swamp unknowingly and before we could halt, were in a red clayey mud up to our

knees. Luckily enough we grasped a rotted log that had fallen some ages ago and were able to make some progress. We soon came upon a stand of trees that my shipfitter (who is supposed to know!) claimed to be teak. I chopped off a few chips with my hunting knife, marked our path down and made mental plans to return with a crosscut saw. Getting ourselves out presented a bit of a problem and to get wood out seemed quite impossible at the moment, but I had resolved since I had found some teak, I was going to bring you out a log.

Standing on the dock awaiting our motorboat to take us back to the ship, a small landing craft stood alongside offering to give me a lift. In the course of our social amenities I found that the senior officer aboard was in charge of a sawmill back in the jungle on a small island ten miles from where we were anchored. He told me that the chip of wood, supposedly teak, was really a soft white wood but if I came up he would let me have all the teak I wanted.

Three days later I obtained a forty-foot motor launch for my own use and set off for the logging mill. As luck would have it the approaches to the landing were littered with coral heads and we went aground three times before we made a landing. After going through a native village and stumbling over an almost impassable hill, we arrived at the logging camp only to find it deserted. It was a partial victory over flora, fauna, and nature, for we *had* located the place.

It was getting late by this time so I took the helm and started across the bay to pick up a few men and make post-haste for the ship.

Now the angels had definitely forsaken me. As I attempted to make a landing a terrific wave hit me and set my bow high and dry on the beach. After an hour of piddling around, not the least being to send several men over the side to lend their strong backs to a powerless motor, we got the launch afloat.

Then the devil began to leer at me! I had just set my course when the engine fouled, stopped. This really caused a bit of a sweat! In the middle of a choppy sea with darkness fast settling and no power! One of the men is a good swimmer. He volunteered to swim to the beach and look for help. All right, I said, and he jumped in. Then I was scared at having given permission to him to carry out his rash act! We all heaved a sigh of relief to see him drag himself ashore and crawl up the beach.

He found help and we finally got back to the beach. The officer in

charge told me it would be several hours before he could tow me back to the ship. Had a spot of dinner at the officers' club and hurried away hoping to irritate the officer into speeding up my tow, only to be greeted with a message from our ship that she had to leave suddenly. *And now I'm on this damned rock and no ship!*

This morning, after about as much red tape as it takes to have a baby, I finally got my launch into dry dock and had it repaired. To make a rather tedious story short, I returned to the logging camp, sawed off a piece of teak that it takes two of us to carry, also a smaller piece of wood — don't know what it is. We got fouled up in a mud bank, but anyway, I've got the wood! Though still it's not back to the ship — wherever *it* is. The teak is too large to send to you from here, but I will send the smaller piece of wood.

Write and tell me what's going on in the studio these days.

As ever,

Max

That was the last letter I had from him. The small log of wood arrived in time. The teak? Probably in the Pacific somewhere.

A few months later the news came that Max had died suddenly of pneumonia. I looked at the hunk of wood he had sent, the address still on it in his handwriting. Whatever I made out of that wood had to be special. That log has been in my studio ever since, waiting. And now as I am writing this book, it seems that the right time has come to use it. So here it is, Plate 61. I will do a girl's head in it; the sort of tender little thing Max would like.

This digression to tell the story: shall we call it a little memorial for a swell guy?

The first illustration, Plate 61, shows a rough drawing in white ink on the log of wood. This is no more than an indication of the size the head is to be with the general placement of the features.

Plate 62 shows the carving begun, using only the one inch gouge and 1¾ inch chisel. The greatest projection on the face is the nose. There are exceptions to this, but this carving is not to be a caricature nor a "character" study. Therefore the nose is protected and the first problem is to cut back until the nose stands out almost to its furthest projection.

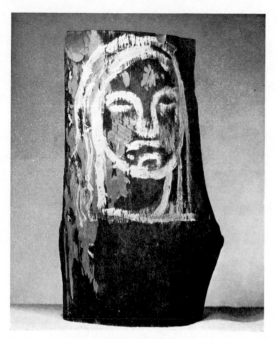

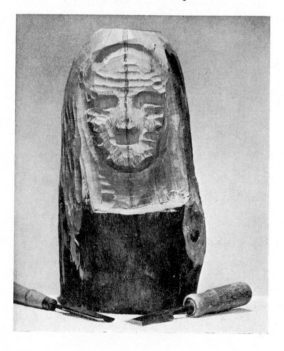

Plate 62. Beginning to carve. The line down the center is important.

Plate 61. The log that Max sent me, with indication of head to be carved in it.

From the very beginning you must remember that a face is roughly egg-shaped. "Oh yes," most beginners say, "I know," and go ahead making the face flat! But an egg curves in all directions, so that every silhouette shows an oval, not just the outline facing toward you. So, work away toward the sides from the nose, remembering that it is an oval shape you are carving. The eyes curve from the inside corners back toward the ears; the mouth, chin, eyebrows, and forehead also curve from the high center toward the neck and the hairline. This may well be the most difficult thing for you to learn in carving a head. There is a purely mechanical thing to remember that should be of great help to you — keep a center line, as shown, drawn from the top of the head straight down the center, through the nose and chin to the base of the neck. This is very important — that line acts as a guide at all times. When you cut the line away, put it back at once, even if you do not think you will need it: you will. If you delay you will forget to do it, and after carving a bit on one side, you will remember about the line and then you may get it slightly off center. So put it back the minute you have cut it away.

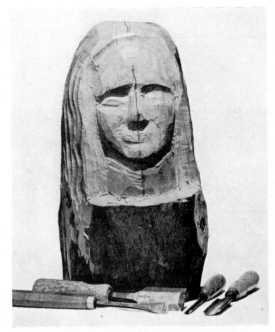

Plate 63. Note difference of expression
between two sides of face.

Plate 63 shows the carving more ad-
vanced. Notice that now I am using two
new tools: a small ⅜ inch gouge and a one
inch fishtail chisel as well as continuing
with the large chisel and the gouge with
which I started. Now some expression is
beginning to come into the face, especially
on the left side. I refer to the left and right
of the photograph, not the face itself. My
usual practice is to keep the expression the
same all over the face, but here I am devel-
oping one side at a time so you may see
what takes place. Just a stroke or two will alter the whole expression of a
face and it is here that the artist in you begins to function. You can make of
the face what you will; it can be a sensitive, tender thing, or it can be coarse
and brutal; it can be sorrowful or happy. That is up to you. But of course
you should have decided what the general expression is to be before you
have gone this far.

On the left side, at the inner edge of the eyebrow at the top of the nose,
see that one little stroke? If it were repeated on the other side, the face
when finished would have a slightly rueful look, or if accentuated, a look
of suffering. The slant of the eyebrow also has much to do with this change
of expression. Cover the right side of the photograph, then cover the left.
You will notice that on the left the eyebrow coming to a point at the nose
gives a look of grieving, whereas on the right the more rounded brow por-
trays a certain calmness.

You will notice, too, that the entire left side has been cut deeper than
the right. Little has been done with the nose as yet — it is just released a
little more by deeper cutting at the sides. But look at the mouth: on the

95

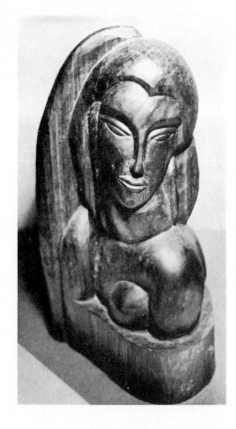

left the curved line from the nose to the chin tends to lift the cheek and gives the impression of a smile. The right side is quite grim. The mouth, incidentally, is important — perhaps more so than you realize. Compare Plate 64 with Plate 65. The former is one of the first faces I ever carved. The large head, Race, Plate 65, is comparatively recent. When I carved the early work I did not know, or rather had not noticed, that the shape of the mouth is like a mound sliced across. It is as if this mound were made of rubber and when cut, is pulled away, slightly revealing the inside. It seems to me the French "bouche," for mouth, is a better word than ours, for if you pronounce "boosh" you can feel the shape of the mouth and the areas around it.

Now let us look at some other heads. Plate 66, Classical Head, owes its grave, yet unsmiling, expression almost wholly to the eyebrows and the calm expanse of forehead. Notice that the eyes are closed. I like closed eyes because they give a withdrawn, "inside looking" expression to the face. This, more than anything else you can do, gives a mysterious quality. A certain air of mystery never hurt any work of art since it helps to make one look at it again and again — and the more one wants to study a work of art, the greater the possibility that it is good. Look at the design of this head; the eyes and mouth are essentially the same shapes — mounds cut across with lines — and form a triangle within the framework. The lines from the edge of the eyebrows to the tip of the nose make another triangle within the larger, and again there is another more loosely defined triangle from the tip of the chin to the edge of the brows. While we are looking for

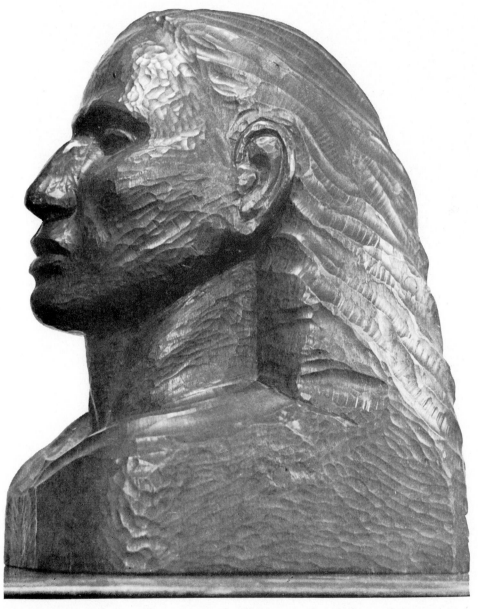

Plate 65. Race. Mouth is like a mound of rubber cut across. Walnut, 1943. 27 inches.

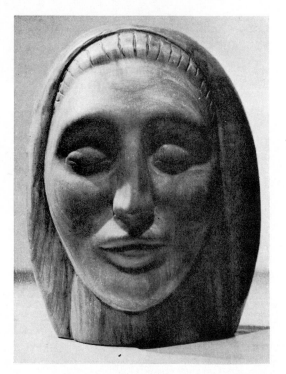

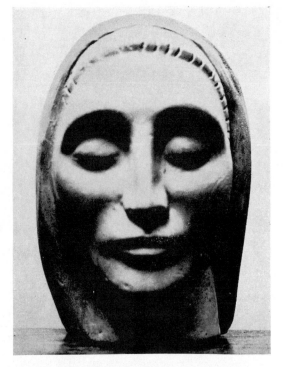

Plate 66. Classical Head. *Plate 67.* The same head in terra cotta.

Notice what a difference the choice of material makes.

triangles, notice that the cheeks themselves, the area with its point in the middle of the nose and following the lines around the mouth to the extreme width of the chin, also make triangles. The eye sockets, too! Really, the face is a maze of triangles — and as you will learn, the triangle gives more strength than any other shape to a piece of sculpture. Yet the effect of the Classical Head, made up as it is of these strong shapes, is suave, gentle, calm.

Plate 67 of the same head is shown here to illustrate an interesting point: this is a cast made from the Classical Head, a cast made in clay and fired. No alteration was made at all. I simply made a plaster cast from the original head in wood, made a press casting in clay and fired it in a kiln. And yet, it might be an entirely different head! The lack of grain in the terra cotta is mostly responsible for this. This picture is shown to illustrate

98

the differences between the two materials as they affect the finished work. The terra cotta head is nice, but the head in apple wood has the play and color of grain to enhance its beauty.

To get back to our carving, Plate 68 shows the face carried a little further. The right side is at about the same stage as the left one was in Plate 63. But now the left side has been taken a long way toward completion. Cover each side and imagine the other as being at the same stage. The left side is already beginning to have the sensitive quality which we hope to achieve in the entire head. The forehead and brow have not changed much as yet; that will come later. For the moment, concentrate on the eye socket, nostril, cheek, and mouth of the left side. The eye, remember, is a sphere that moves inside a round socket, as indicated here. It will be carved a good deal deeper than shown.

The nose deserves a special paragraph. If the face is the "indicator" of a figure, then the nose is the rudder of the face, as someone has called it. A single stroke around the nose can alter the entire face — even more so than strokes in other places, though indeed a change in any part of the face can quickly alter the expression. But in carving the nose, you need to bite your tongue a little with concentration! Looking at Plate 68, compare the blocked-in right with the more finished left. See how delicately the nostril has been cut and yet it is crisp. A certain crispness of line and shape occasionally gives sparkle to a carving that it might not otherwise have; an accent here and there, like spots of light in a painting. If you could run your finger along the left side of the nose you would find little shad-

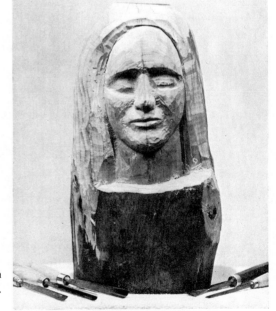

Plate 68. The left side has been taken a long way toward completion.

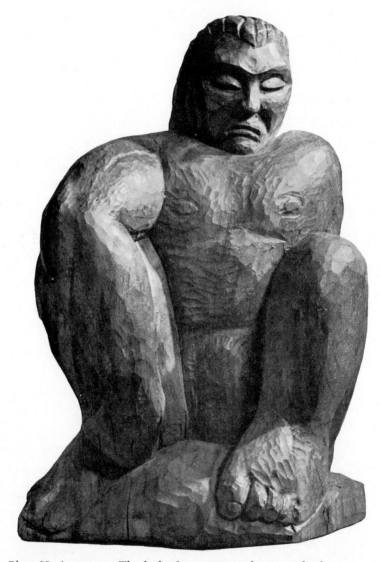

Plate 69. Arrogance. The lack of a groove in the upper lip has a great deal to do with the expression. Kelobra, 1941. 23½ inches.

ings of modeling. And incidentally, this is a good practice: close your eyes, run your finger down along your own nose, then along the nose you are carving, slowly, sensitively. Notice at the nostril that the inside opening echoes the larger outside curve, and feel how all lines point toward the tip of the nose, which is tilted slightly.

Occasionally, and particularly in working around the nose, you will find it advisable to turn over your gouge and carve with the concave side. This is especially good to make the large outside curve of the nostril and the rounded mound at the tip of the nose. The gouge that I refer to is the new one shown at the extreme left. It is almost flat, a No. 4, ½ inch.

If you understand the basic structure of the mouth, it is not so difficult to carve as the nose — but of course it must be done quite as delicately. First be sure that the mound or "bouche" is there. Get the mound properly placed before you start carving the lips themselves, for strangely enough the lips are not any more important than the shapes around them. Most beginners seem to feel that if they get a cupid's bow nicely carved they have done the job and they cannot understand why the mouth looks so artificial. Notice that the nose projects down into this mound and that the mound itself, if carried through to completion, would cut through the nose just above the rounded tip. Notice also that little groove leading from the center of the mouth up to the base of the nose. In some faces you will not want this groove — see Plate 69, Arrogance; brutality, or a certain brute fortitude and strength, are sometimes better portrayed without the groove in the lip. This is also an example of what one stroke will do to alter a face.

Looking at Plate 68 again, notice that the upper lip is roughly in three sections — the slight mound that curves down at the center to fit into the lower lip, and the two wings on either side. The mouth opening is cut with the V tool shown and the modeling is done with a ¼ inch skew or corner chisel. This latter is one of your most useful tools. It will get into corners and crevices that cannot be reached otherwise, and in modeling lips that must be crisp yet delicate, it is invaluable. When you have learned to use it well you will find that almost at will, with a shaving or paring motion, you can cut across the grain of the wood, against it and with it.

101

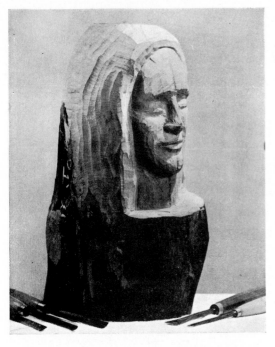

Plate 70. Side view, same stage as Plate 68.

The lower lip is shorter than the upper and fits back into the corners. It should be fullest in the center as shown, and curve in rapidly at the corners. Another thing: it is not even with the upper lip, but slopes backward toward the chin. A side view, Plate 70, shows this. The depression under the lower lip is important and not so easy to carve as you might imagine, defining as it does the base of the lower lip and the top of the chin mound.

The chin usually falls slightly back of the lips; if it does not, you get a chinny or muggy look to the whole face — a sort of false strength such as you see in caricatures of movie heroes. Projection of the chin does not necessarily mean strength; it often means quite the reverse. The chin as shown in Plate 70 still has to be cut back some.

Study the entire face, Plate 68, feature by feature, and see what should be done, what should be altered, what should be played up, as if you were standing at my elbow and were going to tell me what to do next. Forget the right side, as it obviously must be carried to the same state of completion as the left.

The forehead? Nothing has been done here as yet. It must slope back more from the face; the hairline must be put in so that the hair really grows out of the forehead and is not seemingly appliqued on as if the face were a mask. There must be indentations at the temples; the eyebrows must be indicated — probably not indicating actual hair, but rather the shape of the brow. In sculpture it is always the shape, the shape, the shape! No amount of cutting on hair or fussing with delicate little details will compensate for

102

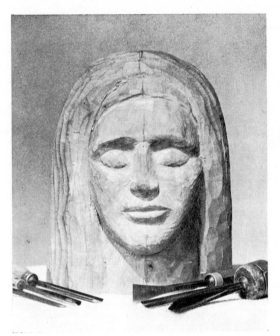

Plate 71. All the features have had some work done on them.

an amorphous foundation of shape. While we are studying the forehead and its general contour, always keep in mind that the widest part of the face is at the cheek bones just below the eyes — most beginners make the forehead too wide. Of course there are exceptions to all these rules, but first you must learn to carve the "general" face and later you can indulge in exceptions. But do not be like the little girl taking piano lessons who played everything with equal gusto or lack of it, and when questioned, replied, "Teacher says not to put in any expression until she tells me what to put." This is not the only head you will carve; I hope there are many young sculptors studying this book who eventually will be able to express anything they wish.

But now what else is to be done? The eyes are no more than blocked in: they are another decisive feature. If the nose is the rudder, the eyes are the windows through which we look into the person behind the face. The cheeks are too flat; must be rounded more at the outer side. The modeling around the mouth must be refined. The chin cut down and given more definite shape. And the neck? It, too, must receive attention to lose that goitre look. The hair, softening the face, has not as yet been carved.

Plate 71: all the features mentioned above have had a little work done on them. The top of the head has been cut off about an inch. The end of the log had checks in it and most of them have been eliminated in cutting off this excess wood. The base has been sawed off entirely, because it was beginning to interfere with the carving. From now on the head will be clamped either at the sides or at the top and bottom. You can see the vise

103

marks on the sides in Plate 72. Notice in this same picture that about an inch has been removed from the back of the head. This was intended to be removed as there were checks and imperfections in the wood. Incidentally, if you will look closely at the bottom, left-hand side, you will see the fibrous quality of this wood. I did not know from what kind of tree it came until my good Siamese friend, Ayus Isarasena, happened to stop by the studio. Since he had known Max I told him about the wood, saying that it might have come from his own Malay Peninsula. Ayus looked at it closely and said that he did not know the name in English, but that the Siamese call it tengrung. It cuts not unlike apple, but is more fibrous; it is about the same hardness as apple — that is, pretty hard, though not nearly as hard as ebony or lignum vitae. A fibrous wood of this sort is difficult to cut clean as the fibers have a tendency to splinter.

In Plate 71, notice particularly what has been done around the forehead. It is much flatter, and the cutting of the hair mass has seemed to lower it.

Plate 72. Notice fibrous quality of wood at lower left.

Plate 73. View from below. Look at your work from all angles.

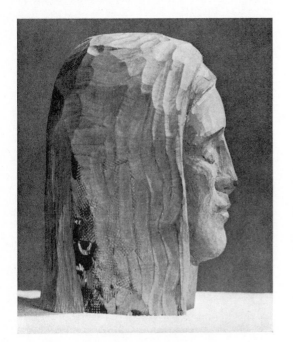

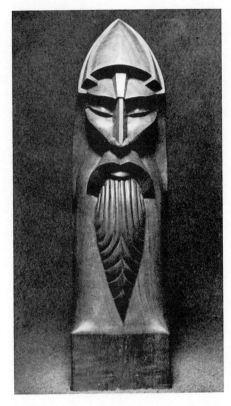

What is to be drapery over the head has been cut
back on the right side. The neck has been cut back
from the chin and rounded a little. Nearly all the
work now is being done with hand tools; I am
using the mallet only occasionally to remove a
large mass. There is still a good deal of small shap-
ing to be done. The view from below, Plate 73,
shows that the left side, around the mouth, is cut
a bit deeper than on the right; the left cheek is
slightly flatter. In working on a head, or any other
carving, it is always a good idea to study it from
the bottom, the sides, the top — from every angle.
Otherwise the head is apt to become lopsided; one
side of the face cut deeper than the other, one cheek wider, or something
of the sort. We do not want absolute symmetry, else a mechanical appear-
ance will result. See Plate 74, The Patriarch, as an example of work that is
too symmetrical. This was carved at a time when as discipline I was trying
to be as mechanically perfect in my carving as possible. You don't need to
worry much about being too symmetrical in your work for there are bound
to be slight discrepancies, which are good since they give a more lifelike
appearance to the face. As you know, your own face is not exactly the same
on both sides — no one's is. In carving, make the two sides as alike as you
can, but not to the extent of measuring — do that only with your eye; try
as hard as you will, there will be enough difference.

Plate 75, more than Plate 73, shows how different the sides are. The
right cheek is much rounder, although in Plate 73 it looks flatter! Also the
left side of the face, Plate 75, seems much broader than the right. It is

105

Plate 75. View from above. Study carefully and compare with Plate 73.

amazing how small an amount of wood it is necessary to remove to remedy this. Study these two plates, 73 and 75, and see how many differences you can find in the two sides. And remember always, when you are carving, to look at your work from different angles.

As well as looking at the face from all sides, it is another good practice to change the source of light; that is, to light the face from directly overhead, from the bottom, then from each side. From every angle observe the changes that occur, also the differences in shadows cast by the features. It is said that Rodin used to go all around his figures with a lighted candle, studying the effect of light and shade. You can use a flashlight or a light on an extension cord. Sometimes a shadow cast by a cheek will tell you more than you can see by merely looking at the feature in a direct overhead light.

Going back to Plate 71, you will see that the center line is still drawn on the face; note also that I have drawn a pencil line at the bottom of the eyes. This line will show you what still has to be done. The modeling of the two eyes is not the same, and we do not want the girl to be either cockeyed or crosseyed! Even if the eyes are closed the modeling must be about the same as if they were open, for the rounded part indicates the pupil of the eye and the placement of the eye under the lids is most important. At this

106

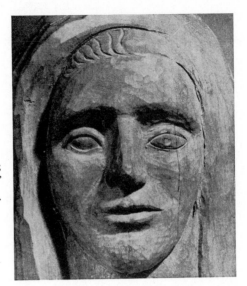

Plate 76. The left eye carved; right eye with "realistic" detail of pupil.

juncture I am tempted, as always, to leave the eyes closed. But we shall open them just to show you how an eye is carved.

There is still much refining to be done, although if you look back through our various steps you will see we have come a long way. The chin has lost its muggy appearance, the entire face has taken on more expression. There is, however, a slight oriental cast around the eyes that does not please me. Let us see what can be done about that. Also the head dress is not quite right. We are not going to make actual folds, since they might detract from the face itself, which is the more important thing. Nothing is more unfair than to do a mediocre face and then carve an intricate head dress, or go to town on carving the hair, either of which is much easier to do than to carve a good face. By doing such a thing you contribute to what I call the "Oh and Ah" school of art. People look at the tricky folds and appurtenances and say, "Oh, how did you ever do that!" or exclaim over the beauty of the thing, when they are not talking about its beauty at all, but rather expressing their admiration of technical display.

Now let us see what we can do about the eyes. Plate 76 shows the left side fairly well carved while the right side has been left as it was except that the first lines have been cut around the eye and a pupil has been added

107

to show how horrible these "realistic" effects can be. There is a certain charm to early Greek and Etruscan sculpture with the eyes fixed in a stare such as this. For all we know, the Etruscans may have had eyes that popped a bit! But let us try for another kind of charm.

To begin with, as pointed out before, an eye is a sphere that moves inside a round socket, therefore we must have some feeling of this roundness. The lids pattern the sphere of the eye into an oval. And these lids are in themselves very important because their shape is altered by the movement of the eye. When I say the eye is a sphere, I am speaking in general terms. As a matter of fact, the lens of the eye makes that part protrude a bit beyond the sphere. Hence when you turn your eye to one side, the lid is pushed forward by the lens. The upper lid, like the upper lip, is longer than the lower and comes out over it.

But look at the picture, which will tell you better than words. At the inside corner of the eye there should be a slight indentation for a tear duct. This indentation would show more clearly except that the edge of the small gouge I was using nicked at this juncture! And incidentally, I do not recommend this tengrung wood or anything like it, for a beginner! While I have been carving the eye, one after another of my small tools has become nicked — and very small tools, with eyes as poor as mine, are difficult to sharpen well. You no doubt have said already, "Why didn't he stop and sharpen that gouge as he told us to do?" The answer is that I don't try to sharpen these small tools myself because the edge of a gouge smaller than ⅛ inch is much too fine for me to see.

Notice how much deeper I have gone into the wood around the eye. The one on the right has not been cut as yet and shows where we started. Also notice how much the entire expression of the face has been changed. Cover the right side, then the left. While carving the eye alone, the face has taken on a dozen expressions. She was an old woman leering at me; she has been crosseyed and cockeyed, lecherous, sneering, coaxing, vicious, sweet — everything! You have to keep your wits about you when you carve an eye, for though to my mind it does not match the nostril in subtlety, it certainly does in precision. It is very easy to break off an eyelid by under-

cutting, or a wrong angle of the tool may do the same. "Careful" does it at this stage. You bite your tongue and breathe lightly; or if you're like me, you groan.

The tools used on the eye were the ¼ inch skew or corner chisel for most of the rounding; three gouges, ¹⁄₁₆ inch, ⅛ inch, ¼ inch. Do not use a mallet on these. Carve with your hands.

You will see that I have put in the hair on the left side. This is carved as simply and in as straightforward a manner as possible. So many times students have come to me to ask, "What's wrong with the hair?" and show me a hodge-podge of lines, as if they were carving a haystack, with no indication of mass, texture, or design. They had obviously never observed hair. Plates 77 and 78, Woman with Bare Feet and Goodelman's Empty

Plate 77. Woman with Bare Feet. Mahogany, 1940. 15 inches.

Plate 78. Empty Plate, by Aaron Goodelman.

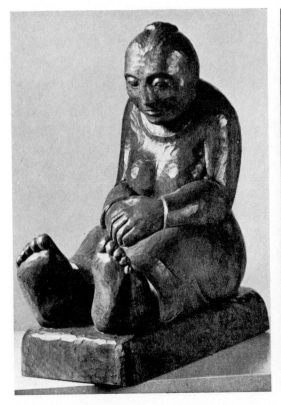
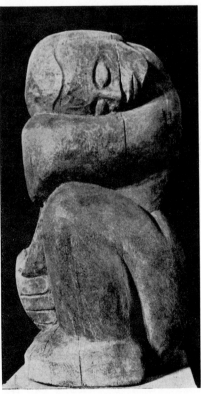

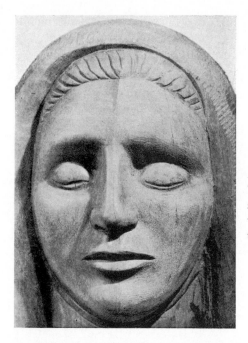

Plate 79. The eyes are closed again! The main thing here is that the left side is finished; the right side has been worked over with riffler files to remove tool marks.

Plate show two different treatments of hair; both indicate the mass, but there is a textural indication in Plate 77. When you carve hair you have to carve an approximation of it, for you cannot possibly reproduce the stuff in wood. It's just about the only feature that cannot be realistically reproduced; you can, however, give the feeling of hair if you observe it carefully and reproduce its essential lines, masses, and arrangement. The sculptors of Greece, the Renaissance, and many contemporary ones were tricky enough with hair to fool you into feeling they have carved the actual thing, almost hair by hair, but of course they have not. Observing closely, you will see that it was through knowledge gained by observation, then by translation into essential design and mass that they achieved the effect. I do not happen to be interested in portraits of hair nor in contributing to the "Oh and Ah" school of art. To my mind, the Egyptians — great sculptors that they were — carved hair better than anybody. They gave an adequate representation of it and let it go at that — with the result that hair is not a distracting part of the whole yet covers the subject's baldness!

Plate 79 shows the head nearing completion. The open eye did not seem

110

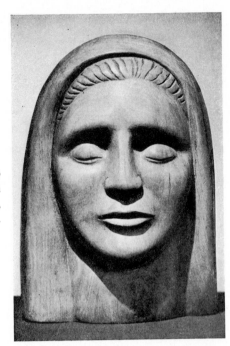

Plate 80. The Novice. She seems to smile as if she knew she was hidden in the log all the time! Tengrung, 1946. 9 inches.

to suit the subject and so, as you see, I have closed it. This is a very simple operation: just carve the eyeball back again to an oval and cut the opening between the lids as shown. In this case the eye had to be made a bit deeper, but it could have been cut even more deeply: one usually errs in not having the eyes deep enough in the head.

Notice that the chin has been cut off a good deal, and it will have to have even more cut off, an eighth of an inch at least. The lips also are just a trifle too full.

But the main thing in this picture is the finish. The left side is finished smooth, that is with riffler files and sandpaper, as described in the chapter on Finishing. The right side was smoothed down with the riffler files only. If you look closely you can see the tiny scratches made by the teeth of the file; sandpaper removes these easily even in the hard wood we are using. Compare this picture with Plate 76 and notice what a difference there is after the marks of the carving tools are removed.

Notice here, too, that the head dress has been cut down somewhat and still more must come off. Notice also that under the chin there is a sug-

111

gestion of a cloth such as is worn by many nuns. That has given me a title for the head: she shall be The Novice.

Plate 80 shows the completed head. The features have been refined, the head dress made to conform to the design of the whole, the entire face finished as smooth as possible. She seems to smile, as if knowing she had been in the log all the time, merely waiting to be released! I hope Max would have liked her.

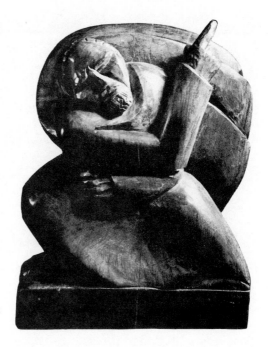

Carving
IN LOW RELIEF

LOW RELIEF, or bas relief, has never particularly interested me as a sculptor; I would rather make a painting. Relief carving, however, does have its uses in making large decorative panels, furniture decoration, bases for sculpture, hence we will touch on it here.

First, let us look at some examples. Plate 81, Tiger, Tiger, is by William Zorach. This is in oak and is interesting to me for its brilliant foreshortening. Although the carving is fairly flat, the paws seem to project and there is no feeling of distortion in the bend of the neck coming around as it does from the back. The surface treatment, especially the pattern of tool marks suggesting stripes, is noteworthy.

Plate 82 shows my Mandolin Player. This is a decorative panel, one of my early works, and is shown here as much for its faults as its virtues. I hasten to say, to forestall criticism which has probably already come to your mind, that it was done at a time when I was very consciously under the influence of the sculptor Mestrovic. The subject matter, the treatment of the hands, the face, are typical more of his work than of mine. The hair

113

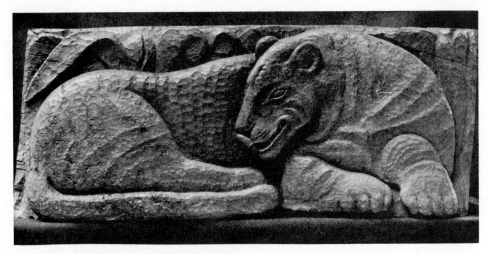

Plate 81. Tiger, Tiger, by William Zorach. Oak.

is not well done, as you can see. The eyes and mouth are more ambitious than skillfull. But the lower part of the carving — that is, the mandolin, the hands, and the drapery — cut very shallow as it is, is pretty good relief carving.

To get back to Mestrovic for a moment: his bas reliefs are, technically at least, among the best of our time. The cutting is very slight, which results in low modeling — but the modeling is so skillfully done that the projection seems to be in almost full relief. I am sorry that I have no photographs available of his fine carvings; however, a book showing many of his works is available at most libraries and I am including it in the Appendix.

My advice to any sculptor would be to study the relief carvings of the Egyptians. This is low relief at its best; extremely flat as to modeling and yet if properly lighted the figures seem to leap from the stone as if they were in full or high relief. I might point out here that high relief has little relation to low relief, as it very often is carved almost "in the round," being attached only at the back to the panel or wall upon which it is executed. The Elgin marbles in the British Museum, part of a frieze on the Parthenon, are excellent examples of high relief.

114

Plate 82. Mandolin Player. Mahogany, 1937. 20 inches.

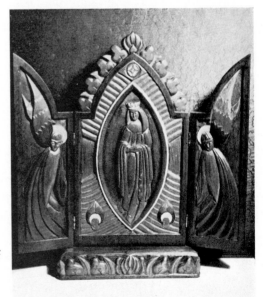

Plate 83. Altar piece, Nativity. Mahogany, 1937. 20 inches.

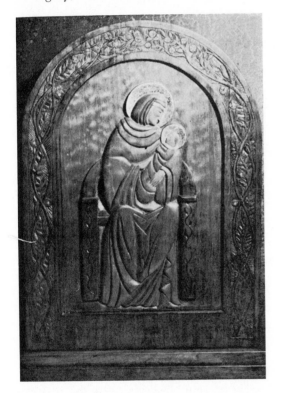

Plate 84. Triptych, The Queen of Heaven. Mahogany, 1937. 18 inches.

Plate 83 shows an altar piece, The Nativity, and Plate 84 a triptych, both examples of polychromed relief. By "polychrome," I mean that the wood was touched with color and the halos were covered with gold leaf. You will find more about this and the way it is done in the chapter on Finishing.

Although the triptych might have been more effective had it been painted rather than carved, the altar piece certainly is better as a carving because of the beauty of the wood. I am sorry this is not reproduced in color so that you could see the rich greens and reds of the foliated border, the tawny grained mahogany, and the figures touched with red, blue, and gold.

How is low relief carved? It looks much simpler than it is. Plate 85 shows a drawing on a piece of mahogany. The subject is the Pieta and it is by the young sculptor Peter John Lupori. When I told him that I did not want to make a relief carving, but that a chapter on the process should be included in this book, he very generously offered to make a carving for me to use.

The drawing was made on a piece of paper the size of the block and transferred with carbon paper — single-faced carbon, this time. Plate 86 shows how simple the first cutting is — or rather, how simple it appears. Bas relief requires more knowledge of modeling than full relief does, if the result is really good. In Plate 86 you will see the two tools used; a ¼ inch V and a ¾ inch gouge. The lines are first incised with the V, then the background removed with the gouge. So far it is easy enough: certainly almost anyone can do this. And as you can see, the relief, merely outlined, is quite effective. However, it takes real craftsmanship to bring the relief to completion as shown in Plate 87. The cutting here is in no place deeper than ⅛ inch, and yet see how richly the forms emerge from the background. The face of the Mary and also of the Christ are cut very shallow, not more than $\frac{1}{16}$ inch. A flat chisel such as the fishtail shown before was the only tool used for the modeling, although a ½ inch skew or a small carpenter's chisel could be used.

116

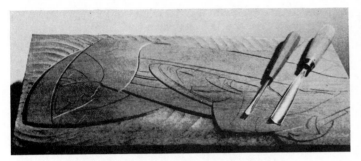

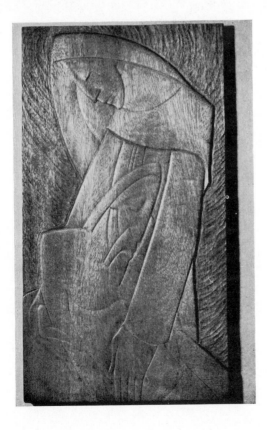

Plate 85, right above. Drawing for the Pieta on mahogany block. *Plate 86, left above*. The lines are incised with the V; the background removed with the gouge. *Plate 87, left*. The Pieta by Peter John Lupori. Mahogany, 1946.

When the carving was completed, the entire surface was sandpapered — beginning with No. 1 paper and finishing with 05, and the wood treated with linseed oil.

Have a try at it. You may find that you like relief carving very much. I would suggest that at first you take the carving no further than is shown in Plate 86, and try to see how very shallow you can make the cutting. Keep the forms simple. Watch carefully that you do not cut deeper with the V in one place than you do in another: in other words, try for uniform depth of cutting throughout. Before you make a carving with the entire surface modeled, try making one with only the outside edges of the figure rounded off.

Incidentally, it is very easy to fasten the block to a table for carving. You can tack a strip of wood to the table on three sides of the block. This should hold your block firmly. However, a still better way is to cut a piece of plywood about three inches larger than the block you intend to carve, then fasten the block to the plywood with three small screws in the back. The plywood can then be nailed to your table. This holds the block more firmly than the strips nailed on three sides.

Perhaps this is as good a place as any to go into a very special problem which often confronts the carver in wood, the problem of finding blocks of wood of sufficient thickness for a carving in the round. It is difficult to obtain blocks of wood more than six inches thick — of course, I am speaking of well-cured wood. You can always use logs of wood if you are willing to accept the large cracks which are almost bound to appear. Even so, it takes a long time, sometimes years, to cure a log of wood and meanwhile ideas will not stop coming just because you do not have a properly cured log at hand!

As I said, it is difficult to find well-cured blocks of wood more than six inches thick; however, at almost any lumber company you can always find kiln-dried wood from one to three inches thick with a width of twelve inches or more. Hence it seems to me that early in your sculpture career you might well give special attention to the problem of trying to achieve

118

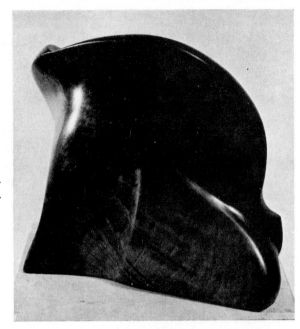

Plate 88. Elephant Form.
Walnut, 1942. 12 inches.

a feeling of three dimensions in pieces of wood that are unusually thin for their height and width. This is a distinct problem of craftsmanship, and for the wood sculptor it is a major one. A beginner should face all problems and try to solve them as an important part of his discipline. If you find that you have only a thin block of wood with which to carve, you can always resort to the solution of carving a low relief, but let us look at other solutions for this thin piece of wood.

Elephant Form, Plate 88, was cut in a piece of walnut not quite three inches thick and approximately twelve inches in height and width. The shapes, flowing into each other, carry the eye around from one side to the other so subtly that we are not distressed by the lack of thickness.

Camel, Plate 89, is the same width and height as Elephant Form, and is only two inches thick. However, every fraction of the two inches has been made to work! There is a subtle interplay of sharp and rounded edges, most noticeable in the silhouette, but also apparent in the sweeping curve that marks the division between neck and body. Notice the sharp line here and what happens on either side of it. On the right is a long slow curve

119

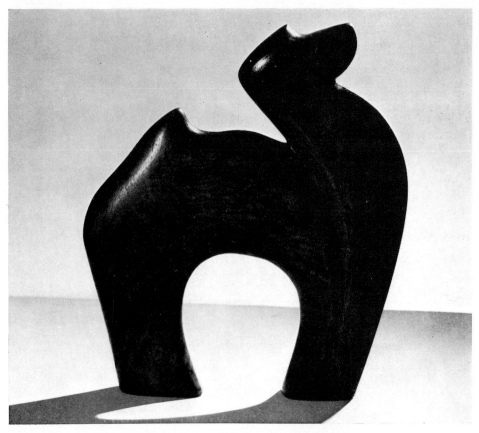

Plate 89. Camel. Walnut, 1947. 12 inches.

to the front which meets again in a sharp edge to make the outline of neck
and foreleg; on the left is an abrupt bevel. The main body curves away
from this bevel. There is no flatness anywhere in the entire figure — this
is the key to the problem of attaining an effect of three-dimensionality in
material of unusual thinness. The arch at the bottom is never exactly the
same thickness; at the two ends it is rounded and as it rises toward the cen-
ter the wood has been brought to an edge. Notice also that this arch is not
perfect. It bulges to the left near the top. I should like to point out here
that a perfect arch would be all wrong; the perfection of a circle rarely
belongs in sculpture. As someone once said — I believe it was Gertrude
Stein — any work of art is a little bit ugly, that is, imperfect. And as I

120

pointed out in the first chapter of this book, imperfection is almost the essence of humanity. It follows that a work of art, the most human of man's creations, must necessarily be imperfect.

But to get back to the little Camel: notice the lazy curve from the bulge in the lower arch to the hindquarters and then the quick, fat curve around to the other side. This might be compared to a slow and a fast passage in music. The contrast makes for excitement. And now for the overall pattern or design of the piece: forget the subject matter and look at the sculpture merely as design. Here are sharp angles, blunt angles, slow curves, fast curves, big arches, little arches. Some are almost complete, others are cut short. Beginning at the very bottom on the right side the eye rises on the curve that seems almost a straight line at first, then curves in a bit more rapidly to the jaw. At that fairly sharp point under the jaw, the eye goes rapidly to the tip of the nose. A straight line leads from the nose to the sharp upturn of the brow, then a slightly curved line, a quick turn, a sharp plunge down to an acute angle, thence a waving line rising to a point forming the tail, then slightly waving down to the rump and a long drop down to the bottom, which is flat but curves around so that the eye is more conscious of roundness than of flatness; then the long lower arch, another flat base for the front feet and we are back where we started. This could probably be set down in a rhythmical pattern that could be translated into music. This is visual music, legato, diminuendo, accelerando, rubato, staccato, for the eye to see. Everybody likes music of some sort, whether the beat of a tom-tom or a full symphony orchestra, and there is no reason why we cannot learn to like sculpture, which if we know how to look at it, is music for the eye.

In Tumblers, Plate 90, the problem of making a piece of sculpture from a thin piece of wood has been solved in a somewhat different way from the Camel. Again the wood is only two inches thick by twelve inches high, but the length is greater — eighteen inches. At first glance you might say that in the Tumblers the problem of three-dimensionality is not solved at all, for seemingly we have here a mere silhouette. But let us analyze the sculpture. As in the Camel, we have no flatness, except in the sides of the

121

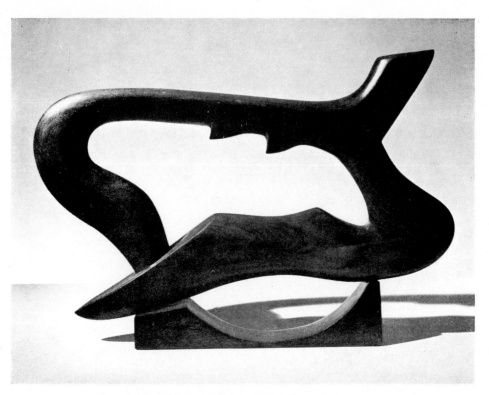

Plate 90. Tumblers. Walnut, 1947. 12 inches.

supporting base. Notice that the curve inside the base is mechanically perfect: it was drawn with calipers and cut on a band-saw. This was intentional. The perfection of this curve tends to accentuate the imperfections of the curves in the figure. In other words, the base was purposely made with perfectly straight and perfectly curved lines. It is mechanical and dull and we are not interested, but this dullness serves a very good purpose — our eyes flee from it. Starting at almost any point in the base, our eyes leap up into the intricacies and involvements of the main body of the sculpture. If, in music, the Camel might be compared to a tender, almost sentimental, little passage, the Tumblers is a ribald scherzo! Our eyes are knocked about much as our ears are by the fast movement of Beethoven's Ninth Symphony!

Perhaps it would be well to explain the subject matter. Have you ever

122

seen two boys take hold of each other's ankles, then roll in great awkward lunges along the floor like a misshapen hoop? This is the idea back of Tumblers. There is no attempt to describe the shape of the two figures; no, we are describing here the *movement* of the figures, the awkward lunge, the over and over movement. If, with dotted lines, you should trace the movement in space outside the figure, set up by the positive and negative volumes, i.e., solid and open spaces, and the outline of the sculpture, you would find the movement repeated again and again. For instance, following the silhouette and beginning at the base, extreme left, the eye goes up to a sharp angle, then out along a slow curve that suddenly turns. Now, instead of following the silhouette, allow your eye to follow into space an imaginary curve set up at this point and you will find that after following a long arc, the eye returns to the figure at about the furthermost tip on the upper right-hand side. The same is true of all the projections — they are like springboards which fling the eye out into long looping curves. Although there are no circles completed in the piece itself, the eye is fooled and in our minds we complete the circles. Plate 91 is a drawing of the Tumblers on which I have indicated in dotted lines some of the circles thrown off from the five projections.

Although sculpture is static physically, every good piece of work has movement, that is, sculptural movement. If you look at a photograph of the Venus de Milo, you will see the sort of movement of which I speak.

Plate 91. Drawing of Tumblers showing movement in space.

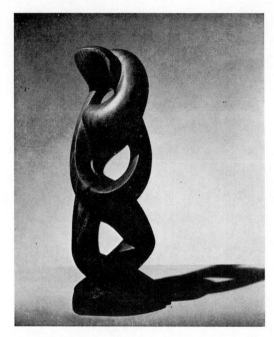

Plate 92. The Embrace. Mahogany, 1947. 18 inches.

The volumes of the figure are so arranged that the eye moves from one part to the other and we are forced into imagining movement. This intentional "movement" in a piece of sculpture can give a significance to the title much more than descriptive details. By descriptive details, I mean those things which explain to us "This is a head. See the nose, the eyes, the hair. Further than that, grief or joy or calmness is depicted." Descriptive details will not give real sculptural movement in themselves. Instead, we get arrested motion. You have seen many examples of this arrested motion in sculpture, especially realistic work done during the nineteenth century: dancers poised on tiptoe, athletes wrestling with animals, horses running. In the Tumblers we have an example of what I mean by sculptural movement almost devoid of descriptive detail.

It is interesting to compare The Embrace, Plate 92, with the Tumblers. In the former, our path of vision is held inside the framework of the outline. There is intentional interlocking of the forms, which gives resulting significance to the meaning of the entire sculpture; without the title as a guide, we would still be aware, visually, of the entwining, the enfoldment,

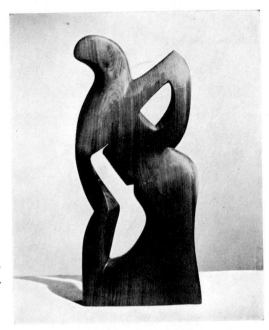

Plate 93. Homage to Mae West.
Walnut, 1947. 23½ inches.

the embrace. The Tumblers does exactly the opposite thing. Our path of vision is forced out into space; the movement is external, not internal; we forget, from a sculptural viewpoint, that the piece is almost two dimensional. There is, however, more three-dimensionality here than at first you might suspect, given by the inward and outward thrust of the various planes.

Homage to Mae West, Plate 93, is still another example of a carving in a thin piece of wood. Here the problem is solved in a slightly different way. The eye is led in and out of the figure, through the negative volumes and around the solid ones. Beyond that, the undulating surface creates a movement that carries the eye up and down, in and out, much as do waves in water. Here, I tried to catch in wood, the undulant, lazy, tantalizing motion characteristic of the subject portrayed. You can almost hear Diamond Lil's famous line of invitation to the boys, "Come up and see me some time!"

We have been talking quite a lot about the problem of making sculpture with a feeling of depth out of thin wood, but in addition there is always

125

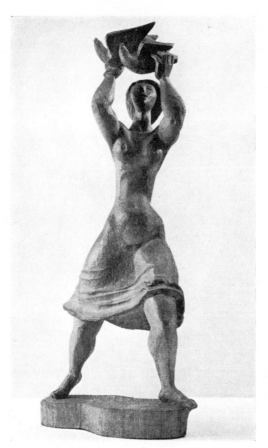

Plate 94. Girl with Birds, by Milton Hebald. Teak, 1947. 4½ feet.

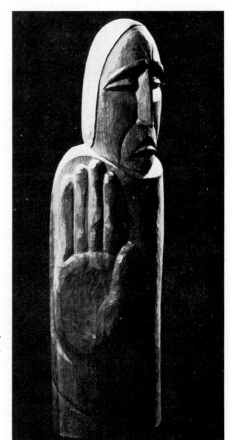

Plate 95. The Preacher. Oak, 1939. 18 inches.

the possibility of gluing thin pieces together to make a sizable block of wood. This process is known as "lamination" and has been used by most wood carvers. Many of my larger sculptures were carved in blocks thus glued together. Plates 15 and 99 are examples. The main technical disadvantage of this process is that the grain changes at every joining so that no effective use can be made of the grain. Also a change in the direction of the grain often makes for difficult cutting.

Plate 94, Milton Hebald's Girl with Birds, in teakwood, solves the problem of the size of block in an interesting way. The figure is 4½ feet tall. It is not made up by the usual sort of lamination, that is, flat pieces of the same length glued together to form one large rectangular mass. Instead, squarish blocks of wood were glued together in a rough approximation of the figure's shape.

While on the subject of gluing pieces together, many sculptors, finding that the block they intend to use has not the proper thickness for, say, the projection of a hand or foot, will glue on a piece of wood at the place where the projection occurs. Although this is perfectly legitimate procedure, I have never done it myself, preferring to solve the problem as in the case of The Preacher, Plate 95. Here, the piece was designed so that the hand and head, though violently distorted, seem normal enough. If you refer to Resurrection, Plate 114, you will see how I solved this problem again. The log of wood used was only seven inches in diameter but was six feet long! By showing the wrapping of gravecloths, which bound in the arms and legs, it was possible to fit the figure into the size of the log and thus solve an interesting problem of design.

We have come a long way from the problem of carving in low relief. However, we have in the meantime covered several solutions for the carving of a piece of wood too thin for an "in the round" figure. My advice to the young wood sculptor is that he learn to carve not only in low relief but in high relief as well. Further than this, he should learn his craft so well that he never will be at the mercy of physical limitations placed on him by the available material. In short, the sculptor should never be at a loss so long as there is any kind or size of wood at hand.

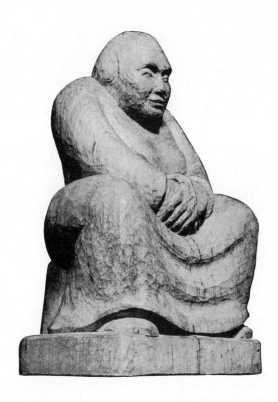

Finishing

WHEN SPEAKING of "finish" in this chapter I shall be talking about two things and you may find it confusing. First, by finish, I mean something applied to the wood such as lacquer, varnish, or oil. Secondly, by finish, I mean the polishing of wood with files and sandpaper. Rare woods such as ebony, snakewood, lignum vitae, teak, and other wax-bearing or very hard woods, are best without an applied finish. They can be left with the tool marks showing or the surface polished with sandpaper and rubbed briskly with a cloth. Porous, soft, or very light-colored woods have to be protected with an applied finish, such as oil, lacquer, shellac, or sometimes varnish.

The finish depends largely upon what the sculpture itself represents. If you have carved a homely figure in oak, it does seem rather willful and perverse to polish it highly, erasing the honest marks of the tools that brought the thing into being. If you have carved a figure such as the Torch Singer, Plate 96, in an exotic wood to fit an exotic subject, a wood with beautiful grain which was chosen to enhance the richness of the forms, then

128

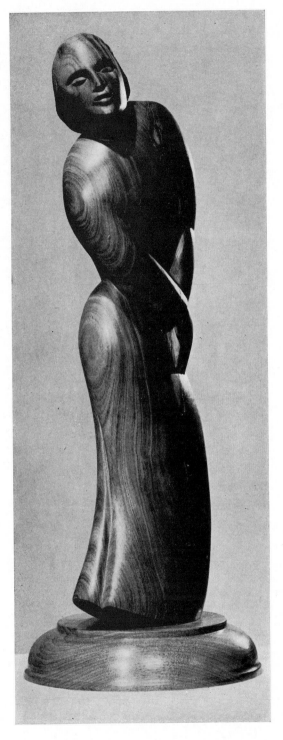

Plate 96. Torch Singer. Highly finished so that the grain shows and enhances the forms. Lignum vitae, 1941. 21 inches.

by all means polish it very highly so that the grain can do its work. There can be no hard and fast rule. Generally, the less finish the better, else your work may have the harsh, impersonal surface of a piece of machine-made furniture.

Yet, sometimes it is necessary to give wood a protecting coat of finish. The light-colored woods such as pine, hickory, pear, white oak, particularly in small pieces of sculpture, do have a way of getting dirty. Sometimes this is not objectionable, particularly when the entire piece has taken on a fairly even tone, which it usually does with age. My own practice is not to apply a finish on the very hard woods and to give as little finish as possible to the more open-grained, soft woods. There are several of these applied finishes which I will discuss later.

But first you must decide whether you wish your piece of sculpture rubbed down or whether you wish the tool marks to remain. If there is any choice, by all means leave the tool marks, for this makes the piece indisputably yours. Tool marks left by an artist are almost a signature. Since

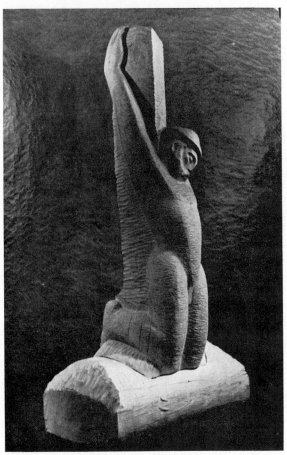

Plate 97. My Kin, by Aaron Goodelman.
Wild cherry.

Plate 98. Nigeria, by
José de Creeft. Snakewood.

Plate 99. The Silent People.
Pine, 1942. 6 feet.

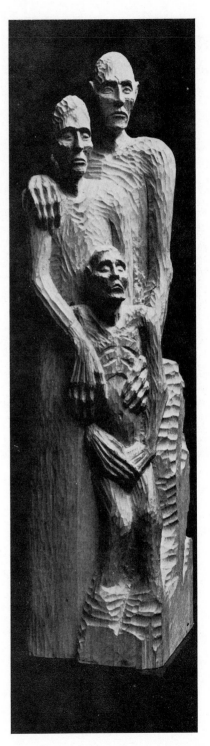

no two people use a tool exactly the same way, one can almost tell the artist from the marks left by the tool. Compare Plate 97, My Kin, by Aaron Goodelman with Plate 98, Nigeria, by José de Creeft. Notice the sensitive yet regular texture Goodelman has left on the wood, compared with de Creeft's broad, irregular strokes. Both of these were probably intentional tool finishes. That is, when the work was carved, the tool marks were perhaps so uneven that the forms were distorted. Thus the artist went over the entire work with a small tool, giving an even pattern to enhance the forms. For another example compare The Silent People, Plate 99, and Laughing Man, Plate 100.

Plate 100. Laughing Man. Mahogany, 1945. 17 inches.

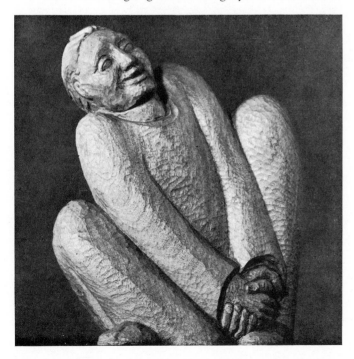

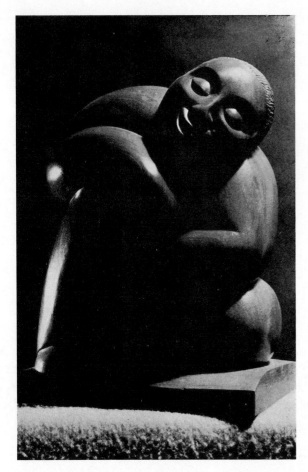

Plate 101. John Henry as a Boy.
Mahogany, 1940. 13 inches.

Plate 102. Cockfighter. Mahogany,
1941. 16 inches.

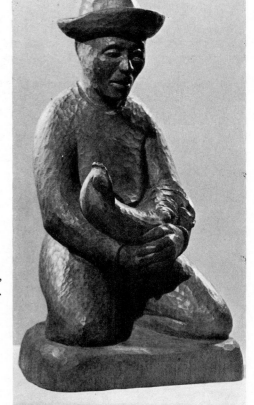

In The Silent People, a life-size group executed in white pine, the actual marks of the tools used in fashioning the piece were left without alteration. I executed this work at top speed, using for the most part a two-inch carpenter's gouge. The entire work was done in a week of furious intensity. I was pressed for time; I needed a large piece for a New York show. The Laughing Man was carved in a leisurely way and, though it is only 20 inches high as compared with the other of 6 feet, I took longer to carve it. And when the carving was done I went over it entirely with a smaller tool to give texture and to refine the forms. I will not say that one way of finishing is better than the other, though I personally find the rougher, direct carving of The Silent People the more interesting. Nothing could be more direct than the carving of this particular group, for it was done without any sketch or model. In exhibitions of sculpture I am always looking for this sort of carving, for works which are "hot" from the artist's hands. Even with their imperfections and general air of sketchiness, I prefer them "hot."

Now compare John Henry as a Boy, Plate 101, with Cockfighter, Plate 102. The John Henry is polished mahogany, all the tool marks erased with files, sandpaper, and steel wool. The Cockfighter is the same wood with the same finishing coat of lacquer, but the tool marks are left. In both instances, since they belong to what I call my Folk Music series, I departed from my preferred practice of making native subject matter in native woods. The reason for this was that in each case, when the idea came to me, I had no suitable oak or walnut at hand and I did have mahogany. But in each case, the finish seems right for the piece. John Henry, a legendary or mythical character, is highly polished, tool marks showing only on the hair. This smooth, refined finish, unnatural to a boisterous folk character such as John Henry, does have the effect of removing the character from us, as if seen in a dream. It is thus that we do know John Henry — removed from us, preserved, refined by the language of mythology. Whereas the Cockfighter, who is not a specific character but rather the cockfighter of any time, hence in existence now — we could find his counterpart any day in Arkansas — is close to us; consequently he was carved in a more immediate technique. We see the marks left by the tool. There is the subtle inference

that he is here now, an existing person; but John Henry, laughing and merry, takes on the aura of a legend.

Suppose that you have completed a carving in mahogany and wish to give it a smooth finish such as that of John Henry. The first thing for you to do is to go over the entire figure with the fine bastard-toothed rasp and erase the tool marks. You will find the rasp too large and clumsy for the small details of eyes, mouth, nose, and all the corners. So for them use the small, variously shaped riffler files. When the marks of the tools have been rubbed away with the files, go over the figure with fairly coarse, No. 1, sandpaper to remove the slight file marks. The chances are that you will find rough places which the rasp did not entirely remove. If so, go over them again with the rasp and sand with the No. 1 paper until the wood is as smooth as you can possibly make it.

Don't cheat. That is, don't leave small scratches and marred places, thinking "Oh, the lacquer will cover that up," because it will not. As the grain begins to show in all its beauty, you will be tempted, as I always am, to hurry ahead and put on some lacquer so that you can get the full effect. But take your time. When the wood is as smooth as you can get it with the coarse paper, go over the figure with 00 paper. As you work with this fine paper, you will find that there is smoothness beyond smoothness! As a last gesture, rub with the finest paper available — the 00 paper after a little use loses some of its tooth and this worn paper is very good for a final rubbing. Rub until you are absolutely certain that the wood cannot be made any smoother. If you are honest about this, not slighting the work, the final rubbing will make the wood like glass. There is a final stage which you will learn to recognize: you have been rubbing with the fine paper and have been able to feel the abrasive cutting the wood and also you will have heard it. Then suddenly there is no more feeling of abrasion, the sound diminishes, you look at the wood and it is shining!

When the entire piece has been given this even "shine" with the last sandpaper, dust it off carefully. I use a brush, then a cloth.

Ten to one, you have not finished the entire piece. What about the bottom? Students almost invariably bring their first work to me saying, "There,

it is done!" When I turn the piece up and look at the bottom they say, "Oh, I didn't know I was supposed to finish that." If it is a quite large piece, half life-size or more, the bottom may be left rough, though in all cases I pre-fer the bottom finished; otherwise it will mar any polished surface upon which it is placed. So be sure to finish the bottom with as much care as you have finished the rest of the sculpture.

If your wood is ebony, lignum vitae, snakewood, or any of the highly figured, very hard woods mentioned before, the sculpture is now com-pleted. If the wood is mahogany, walnut, pear, apple, either soft or light in color, you may wish to give it a protective coating. For this I find dull spraying lacquer is the quickest and easiest to use. This lacquer can be obtained in bulk at the larger paint stores. It should be applied in a thin coat, so get a can of lacquer thinner to make the proper consistency. I pre-fer to apply the lacquer with a brush rather than a spray gun. You can get into crevices and under projections better with a brush, and too a spray gun is rather messy to use. A fine-textured brush about ½ inch is right for small sculpture. By fine-textured I do not mean anything as soft as camel's hair. Red sable is the best. However, I have used a bristle brush from my paint kit and find it soft enough; if given proper care it will last a long time.

Flow the lacquer on with soft, glancing, long strokes. Don't scrub it on and don't dab. Long, caressing strokes, neatly overlapping, with not too much lacquer on the brush, are best. You will notice that the lacquer can-not be put on with absolute evenness. Don't worry about that. Cover the entire figure except the bottom. When that coat has dried, turn the sculp-ture on its side and paint the bottom. Here, since this is the absorbent end grain, put the lacquer on quite thick. This will bind the ends of the grain together and be a protection against moisture, which is more quickly ab-sorbed by the pores of the end grain than by those on the flat side.

Allow this lacquer to dry overnight, or at least for several hours. It will be dry enough to handle in ten or fifteen minutes, but not dry enough to rub. When it is thoroughly dry, rub it all over with fine steel wool. When you pick up the piece to begin the steel wooling, you will notice that the surface has a slight burr and this should be removed. Don't rub hard

135

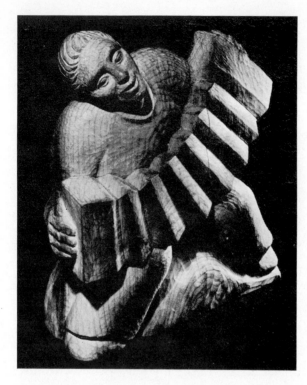

Plate 103. Accordion Player.
Myrtle, 1945. About
18 inches.

enough to remove the lacquer, just enough to even out the thicker places.
The steel wool will make the surface just as smooth as before the lacquer
was applied, and of course the lacquer has filled the pores of the wood so
that no more moisture will be absorbed, and moisture, always present even
in kiln-dried wood, will be held back enough so that even a very dry at-
mosphere will not draw it out fast enough to cause the wood to check.

Now give the piece another coat of lacquer, again remembering to give
the bottom an extra heavy coat. When this second coat is dry, after several
hours or overnight, again rub it down with steel wool. I recommend steel
wool rather than fine sandpaper for the reason that it does not cut through
as fast and also it produces a softer surface than sandpaper. After this sec-
ond lacquering and rubbing you will probably find the piece does not please
you completely — some places may be too dull, others too glistening. There
are two things that can be done: one is to remove the luster of the lacquer,
the other is to heighten it.

136

If the wood you have used is quite close-grained, such as apple, pear, hickory, or if you find that the gloss of the lacquer is distracting, you can obtain a finish such as that of my Accordion Player, Plate 103. This figure is carved from myrtle wood, a hard wood, almost white in the lighter parts. Because of this very light color, I wished to protect it from dirt stains and used several coatings of lacquer. These gave too much shine. My solution of the problem was to remove the lacquer with lacquer thinner. I scrubbed the thinner on with a stiff brush, allowed it to stand a moment, then wiped it clean with a cloth. I went over the entire figure twice, then rubbed it slightly with steel wool. The shine was gone, although enough of the lacquer remained in the pores of the wood to protect it. I finished The Novice, Plate 80, in the same way.

But now suppose you wish an extremely high polish. To impart the final luster and to draw the entire surface into one gleaming sheath, use ordinary paste floor wax. Apply the wax with a soft cloth and after allowing it to dry for half an hour, rub briskly with a brush — I use a scrub brush — then give a final polish with a piece of flannel or any soft cloth. If you have not cheated anywhere along the line, the finished sculpture will gleam with reflected light and the grain will have depths which catch the light much as does a piece of polished granite. John Henry, Plate 101, is an example of this very high finish.

Before going any further, I want to give a little lecture on the care of brushes! Time and again students come to me asking, "Mr. Rood, have you a brush I can use?" Although I have learned to tell them in detail how to clean the brush, I very often find on its return that it is completely ruined. If the student has used the brush in lacquer or shellac, he may have tried to wash it out with soap and water; if he has used the brush in oil paint, he is likely to have tried to clean it with alcohol! Or after using he may have thrown it down carelessly without cleaning it at all.

Now a brush is a tool, and tools are often valuable beyond their cost. Every artist has his favorite brushes, gouges, chisels — irreplaceable! Always clean a brush *immediately* after using it. Do not put it aside thinking you

will clean it later. Lacquer and shellac dry quickly, and once dried in a brush are very difficult to remove without harming the bristles.

While on this subject, I want to tell you how to clean not only brushes used in lacquer, but also brushes used for oils or oil painting. Lacquer brushes should be wiped carefully with a cloth. Press the bristles firmly between the layers of cloth until as much of the lacquer or shellac as possible is removed. If no alcohol or lacquer thinner is available, you can leave the brush this way, since — if it has been wiped carefully enough — not enough lacquer will remain to gum it up. However, it is much better to go further, wash the brush in lacquer thinner or alcohol, then wipe it again on the cloth.

Soap and lukewarm water are best for cleaning brushes used in oil paint. First wipe out the paint with paper tissues or a cloth, then wash the bristles with turpentine, wipe again, then wash the brush with soap and water. I do this at a sink or wash basin, alternately rubbing the brush across the bar of soap and rinsing thoroughly in the flowing water. Keep this up, rubbing and rinsing, until the brush is as clean as new. Don't leave a line of telltale color at the top of the brush where it joins the handle. That is the usual practice of careless people and it is one of the best ways to ruin a brush. Clean the brush *thoroughly* from tip to tip.

And a last warning: don't get your processes mixed! That is, don't try to wash out lacquer with soap and water; don't try to wash out oil paint with alcohol or lacquer thinner.

As I stated at the beginning of the chapter, the least finish on your sculpture is the best. The dull lacquer finish, rubbed down between and after coats, gives an effect of no varnish — it seems as if there were nothing between you and the wood. And this is the effect you wish — just enough finish to protect the wood from moisture and dirt; not enough to give a furniture-like, varnished appearance.

If finishing a rough piece, such as the Cockfighter, of course you do not rub with the files or with sandpaper. If, when you have finished using your tools, you find rough or ragged places, you can rub them down with steel wool just enough to remove the "bite" of the rough place, but not enough

138

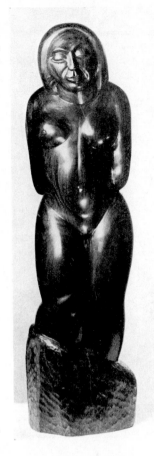

Plate 104. Slow Dancer. Ebony, 1940. 33½ inches.

to mar the edge of the tool mark, for these crisp tool edges give an interesting texture to the surface. Then brush on the first coat of lacquer, allow it to dry, then go over it with steel wool just as described before. After the second coat of lacquer and the second buffing with steel wool, the finish is complete. These rough figures are best not waxed. The roughness of the tooling breaks up the surface enough so that any irregularities in the application of lacquer pass unnoticed. You do not want these rough pieces to have a shine. Dull lacquer does give a slight gloss, but it is not enough to catch light and destroy the subtle play of light-and-dark on the tool marks. However, should you find more shine than you wish, remove the lacquer as described before.

Perhaps it would be well to explain here why a very high finish is not desirable on most sculpture. Look at Slow Dancer, Plate 104. This figure is in ebony and a high finish is desirable, but not as high as shown in the illustration. See how the light falls on the face, breasts, belly, and arm and destroys the modeling. You can scarcely tell which part of the sculpture is rounded and which concave. The face has lost its intended expression. It is as if you greased your face all over and then turned a bright spotlight on it. Where shadows should be, there are pools of light. The whole thing is falsified. Compare Slow Dancer with Night Flower, Plate 32. The latter is not finished as highly, consequently light falling on it does not destroy the modeling.

It is wise to resist the temptation to make everything gleam and glow

139

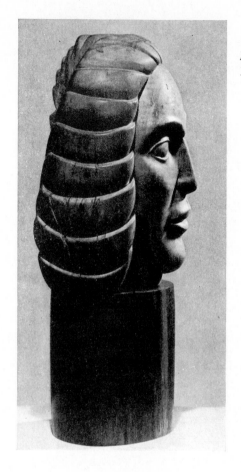

Plate 105. Young Girl. Apple, 1941. 11 inches.

and reserve high finish for very simple sculptures, such as the Torch Singer, which gain in elegance from the finish, yet are so simply designed that the play of light makes no distortion. I might point out here that the Torch Singer has no lacquer or wax on her; she is made of lignum vitae which was sanded down to great smoothness and then the bare wood was rubbed with brush and cloth. Lignum vitae has its own wax content and when rubbed briskly will take on a shine beyond anything one can apply. The same is true of rosewood and teak. Ebony and snakewood are not so waxy and it is sometimes necessary to give them a light coat of wax to bring out their full richness.

Apple, cherry, walnut, and pear have a beautiful surface if left bare of any finishing coat of lacquer. Young Girl, Plate 105, Caryatid, Plate 106, Young Brunnehilde, Plate 107, are examples. The Caryatid has a coat of lacquer on the head dress which serves to heighten the color of the wood and makes a contrast with the face. The Young Brunnehilde is in cherry; the photograph was taken immediately I had finished the piece. With age cherry darkens and richens to a tawny wine color. This is true of many woods — in fact, almost all of them take on a darker and richer tone. A coat of lacquer does not in any way retard this aging and in the case of mahogany even hastens it.

There are several finishes other than lacquer that you can use: linseed oil, which is quite good and sometimes preferable, particularly on large

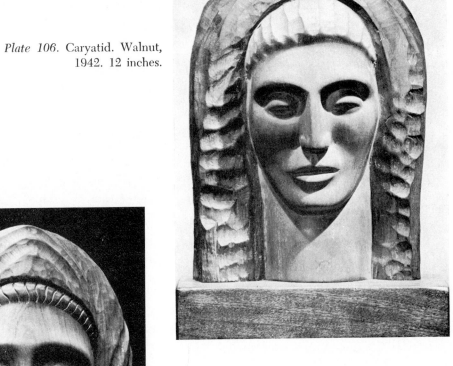

Plate 106. Caryatid. Walnut, 1942. 12 inches.

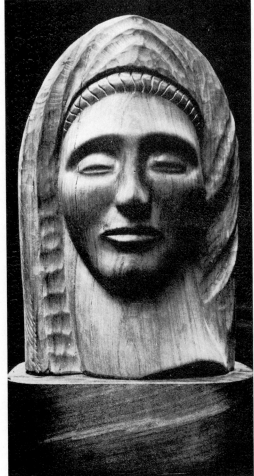

Plate 107. Young Brunnehilde. Cherry, 1942. 14½ inches.

figures in walnut; shellac, which I personally do not like because it gives a hard, brittle surface; penetrating oil finishes, which are excellent; olive oil, with which I have had no experience, but some sculptors have told me they prefer it to linseed.

The penetrating oils go into the wood and dry absolutely without gloss. My only objection to them is that, like linseed oil, they darken very light woods and sometimes one would like to have a wood such as pine retain the original whiteness and darken only slightly with age.

Linseed oil can be applied from the bottle, or if you prefer you can heat it. I have never seen that it made much difference. Usually I treat a piece of sculpture with two or three coats of the oil, which is absorbed into the wood and gives a very slight luster. Linseed oil is almost foolproof on woods such as walnut and oak and its use is most highly recommended. The only drawback that I have found is that it does not entirely seal the wood against moisture, unless you apply so many coats that the oil dries thickly, thus making a varnish.

It is an interesting thing that linseed oil sometimes will swell the outer surface of a not thoroughly dried log enough to close partially some of the cracks. In the case of Eroica, Plate 3, which was carved in a log of freshly cut black walnut, this was true. As I carved, I coated the log with oil, each day covering what I had carved that day. Thus it was possible to continue with the carving and finish it before the cracks got out of control. It is difficult to carve a log which has developed large cracks because the tool is apt to break out pieces of the wood as as it cuts across the openings. This coating with linseed oil was an experiment on my part and in the case of Eroica it was successful, since I worked daily at the sculpture. A trick that will always work, when carving partially cured wood, is to fill cracks with beeswax which has been heated until it is pliable. This holds the edges of the wood firmly so that the gouge passes easily across.

While we are on the subject of beeswax used in this way, I recommend its use for filling cracks in all larger works which seem especially suited to crude logs of coarse wood. An example is The Grandmother, Plate 108. There are several reasons for filling the cracks with beeswax. No log larger

142

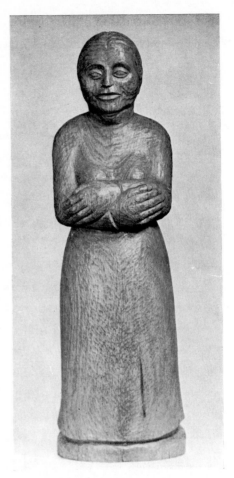

Plate 108. The Grandmother.
Oak, 1940. 30½ inches.

than six inches in diameter is likely to cure without radiating checks from the center. It is almost impossible to carve a log that is checked unless the cracks are filled in some way. If you fill them with plastic wood, the result may be disastrous, for as the log dries in the center, the outside cracks have a tendency to close and if they are held open by plastic wood, even wider cracks will develop elsewhere. However, if the crack is filled with beeswax, as it closes the wax is forced out and you can scrape it off with a knife.

I had a very amusing experience with The Grandmother because of this tendency of cracks to close. The carving was made in a log of uncured oak. As cracks developed while carving, I filled them with wax. Some months later I exhibited the work in a steam-heated gallery. After a few days, when I happened to be in the gallery showing the sculpture to friends, I noticed that The Grandmother had broken out with a strange sort of lumpy fur! It was the wax, which I had forgotten, forced out as the cracks closed.

You can match the color of the wax to the wood very easily. This is the way I prepare it: cut a cake of beeswax, which you can buy at a hardware store, into small pieces. Place these in a metal pan. Take a small dab of oil color—burnt sienna, raw sienna, burnt or raw umber, ochre are the colors

143

most often used — and dissolve it thoroughly in turpentine. Very little color is necessary to match the color intensity of the wood. The wax will weaken the color somewhat, but it is better to be on the weak rather than the strong side. Use about two tablespoonsful of turpentine to a cake of wax. Pour the turpentine, in which the color has been dissolved, into the pan with the wax, then place over a low flame and melt. Don't allow the mixture to boil or come to a smoking heat; just melt, that's all. Then take it off the fire, pour into a shallow dish such as a plate and let it set. You can cut this into strips, mold it with your fingers, and press the soft wax into the cracks. Don't muss across the surface, but press it firmly back into the crack. You will no doubt find that some has accumulated around the crack. This can be removed by rubbing with steel wool, which will remove the wax from the surface without pulling it out of the crack.

Plastic wood for filling cracks is not a favorite of mine. It is such an inert material that it neither gives nor takes. On some woods, such as snake-wood, it has worked satisfactorily for me, but more often than not it plays nasty tricks, such as first presenting a beautiful surface and then a few months later breaking away from the sides of the crack, sometimes even falling out. In short, it does the job too well at first, then lets one down later.

When selling a piece of sculpture with checks in it, even if they do not show, it is best to be honest with the purchaser. Let him know that there are checks in the wood, no matter how artfully they may be concealed. If he is a real connoisseur of sculpture in wood, the cracks will not annoy him, as he will know that they are natural to the material. If he insists that the cracks be completely hidden by fill-in, although you, the artist, feel that the cracks should be left there, honest and unashamed, then go ahead and fill them for him and don't worry if they do come open later: serves him right for being insensitive to honesty.

As explained, wax is the best filler for checks in wood which has not yet thoroughly dried. There are fillers, other than commercial plastic wood, which I recommend for use in closing cracks in well-cured wood. One of these is plastic glue. For small checks this can be used pure, with a little coloring to match the wood. For large splits, you can mix wood putty or

144

sawdust with the glue to give it more body. Cascamite is the trade name of the glue I have used in the past and though it does the work very well on small checks, when used in large masses it shrinks away and sometimes, like plastic wood, falls out. Cascamite and Weldwood, comparatively new plastic adhesives, are superior to casein glues, since they are water repellent. In very large slits, pieces of the wood can be inserted and glue poured all around. When a piece of wood is cracked its entire length, and you wish to fill it with glue, be sure to close the ends to hold the glue in. A piece of adhesive or Scotch tape across the end will prevent the glue from flowing out. This of course is easily removed when the glue has set.

A sculptor friend of mine prefers a plaster crack filler to anything else. He colors the plaster with water color and thinks he has been most successful with it. I have never been successful with his method, though he has explained it in detail to me. I would discuss it here, except that I have noticed on some of his works that the plaster has, in time, chipped out, leaving hideous white places. My theory is that the plaster, being as inert as stone when dry, is not good used in combination with a "breathing" substance such as wood.

Plate 109. Il Pensoroso, by Ossip Zadkine. A modern example of polychromed sculpture in wood.

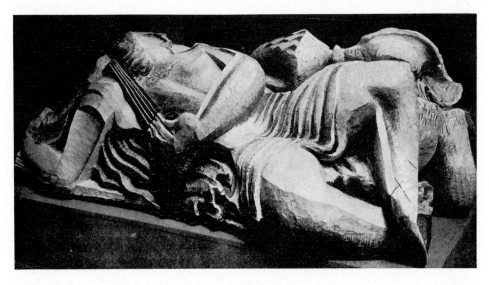

145

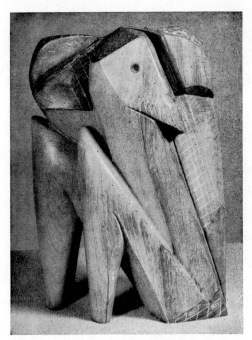

Plate 110. Temptation of St. Anthony. An example of partially polychromed sculpture. Myrtle, 1949. 17 inches.

Lately I have been experimenting with polychrome on wood. Plate 109, Il Pensoroso, by Ossip Zadkine, is a modern example of a polychromed figure. I have not seen this figure, but from the photograph I judge that color has not been used on all the areas, but only for emphasis and pattern at various points. However, the entire piece seems to have been given an undercoating. For this undercoat, gesso is the material most often used.

The process of polychroming is not at all difficult. The wood is given a coating of gesso. This coating may be as thin or as thick as you like, according to how you wish to use it, whether to cut into it to make incised decorations or merely to have it serve as an undercoat for applying colors. Gesso, incidentally, is a mixture of glue and whiting. There are recipes for making your own, but I buy it already prepared. You can buy gesso in powdered form at almost any art supply store. Oil colors are painted directly on the gesso.

In the past my objection to polychroming was that natural wood is so beautiful it seems a pity to cover it. However, one often wishes to heighten

146

the beauty of the grain by a contrast of texture and color. Plate 110, Temptation of St. Anthony, was my first experiment in combining natural wood with colored and textured areas. This sculpture is in myrtle, a yellowish wood with smoky gray and black grain running through it. When finished highly, there are occasional spots in the grain which glow almost with the iridescence of mother-of-pearl. When the Temptation of St. Anthony was finished, I decided to see what spots of color would do to it. I coated various areas with gesso, putting on four or five thin coats until it was perhaps as much as one sixteenth of an inch thick. Then I cut designs into the gesso. If you look at the top of the head you can see the waving lines so cut. Then I painted this with a thin wash of cobalt blue. The area at the upper right was painted a yellowish red. The extreme bottom, left, is a yellow green. These were the only colors used: blue, yellow red, yellow green, and of course the main body of the work is the natural wood color, that is, yellowish with touches of gray in the grain.

When this was done, the piece looked extremely garish and I was ready to take off all the paint and gesso. Before doing so, however, I cut through the coat of paint into the white background, making hatched designs showing clearly on the left side. This white coming through the color gave a certain vibrancy and life to the areas. Much better! Then I took coarse sandpaper and rubbed the color thin in some areas so that the background coating of gesso shone through. I was still not sure whether I liked the piece better with color or without. Not until I had photographs taken, in black and white and also in color, was I sure. Then there was no doubt, for the monotone was not particularly interesting, whereas the color played up certain areas, and the lack of it helped others. Also, since warm colors advance and cool colors recede, the three-dimensionality of the figure was increased in an interesting way.

Another example of this partial polychroming is Leaping Horses, Plate 111. The wood is a rather dark mahogany. Most of the color on the piece is yellow ochre. The wood underneath the yellow areas was left fairly rough, then when the color was painted on, I sanded these areas lightly so that the white undercoating came through with irregular, sand-like texture.

147

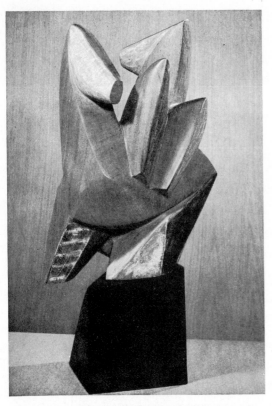

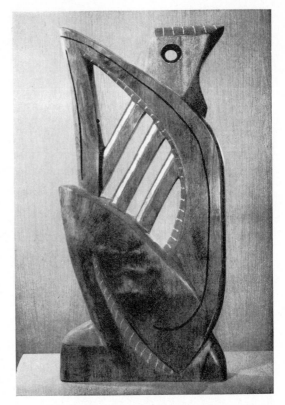

Plate 111. Leaping Horses. Partly polychromed. Mahogany, 1949. 20 inches.

Plate 112. The Harp. Showing iridescent grain in wood. Myrtle, 1949. 3 feet.

There are a few touches of gold leaf here, also. The gold leaf was applied over yellow red, then wiped away so that it gleams irregularly rather than in a solid sheath. Gold leaf must be used sparingly and never used solidly in large areas. When not broken up, it tends to flatten the plane on which it is placed and also has an unpleasant glare.

One other example of partial polychroming is The Harp, Plate 112. This is also in myrtle wood. Those irregularly shaped lighter patches on the thigh are the iridescent places in the grain which I mentioned before. The colors used are gold, scarlet, and brown-black.

In the previous chapter I mentioned the use of color to stain wood. This is an entirely different process from the polychroming described above.

148

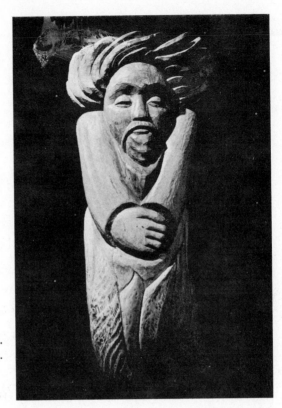

Plate 113. The Burning Bush.
Apple, 1945. About 30 inches.

Colored stains can be used on wood without destroying any of the depth or natural beauty of the grain. The triptych, Plate 83, and the altar piece, Plate 84, were treated in the following manner. Transparent oil colors thinned with turpentine were used. When the wood was ready for finishing, I painted the colors on, allowed them to sink in, then wiped the surface with a cloth. When the colors had dried, I went over the entire piece with lacquer. Except for the halo, on which gold leaf was applied, the grain of the wood is not covered. With the passage of time the colors have richened immeasurably as the wood darkened.

The Burning Bush, Plate 113, was also treated in this way except that I used penetrating oil rather than turpentine as a vehicle for the pigment. The carving is in apple, a rich and beautifully grained wood. Some apple is almost white, but this particular piece was a golden yellow with a brown-

149

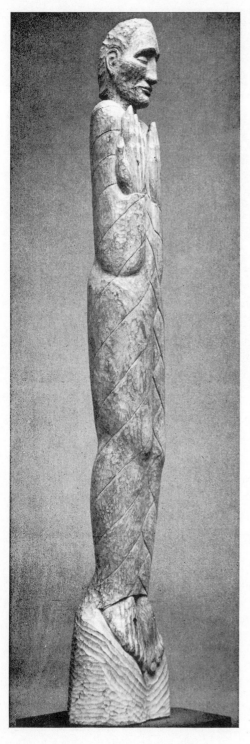

Plate 114. Resurrection. Elm, 1944. 6 feet.

ish flamelike grain flowing through it. In fact, the piece of wood with its flowing grain gave me the idea of The Burning Bush and I made use of the grain the very best I could. When the carving was finished, to study it, I placed it on a pedestal under a light for a few days, a usual practice with me. Very often changes seem advisable and I like to look at sculpture a long time after it is completed to see if there is any way it can be improved. Laurence Schmeckebier, then head of fine arts at the University of Minnesota, came into my studio at this time and after looking at the sculpture turned to me with a mischievous grin saying, "What would happen if you just touched the tips of the hair and the flamelike business around the bottom with red?" The suggestion was enough! I got the color too strong the first time but was able to remove most of it, and the hint of color left was just right.

In the case of Resurrection, Plate 114, I painted the wood for a very different reason. This was carved in a green, freshly cut log of slippery elm, the kind whose inner bark makes good chewing gum, or so I thought when I was a child! It was more or less of an experiment, for I had never carved in elm be-

fore and I was curious to know how much it would split if it were carved green. The carving was done more than five years ago, and to my surprise the wood has not split except for two minute little checks, even though the figure has been almost constantly in a steam-heated room. However, soon after the carving was done, the wood began to darken. Now I wanted it to remain white as it was in the beginning. I realized that it would soon be so dark that the effect I wished would be spoiled. So I painted it with white, then rubbed off as much as possible while the paint was still wet. Just enough stayed in the pores of the wood to give the pallid appearance I wanted without destroying the essential "woodiness" of the whole.

To sum up this chapter with a few general rules for your guidance. If possible, leave tool marks on sculpture in wood. Sandpaper and smooth out tool marks only on those rare woods which have a grain that contributes to the beauty of the sculpture. Use as little applied finish as possible, just enough to seal the wood against moisture. Do not fill cracks in wood unless they interfere with the design or if it is demanded by a patron.

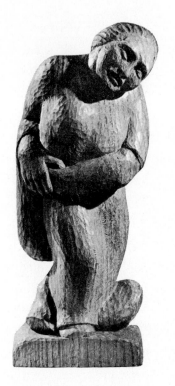

How
TO USE SCULPTURE

AS I HAVE SAID elsewhere, I believe that people are drawn more naturally to sculpture than to any other art. The first object that a baby grasps is a sculptured object, that is, a three-dimensional object, a ball, a block, a rattle, a teething ring. He is familiar with such objects long before he takes any interest in pictures. In all of us the sense of touch develops very early and we carry that sense to a heightened degree throughout our lives. Sculpture gives pleasure and exercise to the tactile sense.

If people generally have this liking for sculpture, why is it that so few have sculpture around them in their homes and that most persons seem so reluctant to buy any? For the most part I believe it is because people don't know how to use it. They think of sculpture as something belonging in museums or galleries. That is where they have seen it — placed on ponderous marble pedestals, and they haven't and don't want those pedestals in their homes! Somehow they do not exercise their imaginations enough to consider how else they could place it. How often we sculptors hear the re-

mark, "I'd like to buy one of your pieces, but I wouldn't know what to do with it. I have a very small apartment." We do not like to say, "Buy the sculpture and I will show you where to place it." Most artists are poor salesmen. So it is that such would-be purchasers are not even helped by those most closely concerned, the sculptors.

The lack of this know-how or imagination applies equally to decorators and architects, who are the logical persons to show how sculpture might be used. Decorators have learned to build rooms around the color scheme of a picture, but for the most part they rarely put their minds to the special accent which a piece of sculpture might give to a room.

People think they know what to do with a picture: the placing of it does not require much imagination. It is hung over the sofa or the mantel and then often forgotten! Fond as I am of pictures, I do not think they do as much for a room as a piece of sculpture does. The painting hangs on the wall, occasionally admired, but the sculpture is right there with you, a tangible object that can be enjoyed with the senses of both seeing and touching. It casts shadows which are sometimes as interesting as the thing itself. It is company for you and almost seems a member of the party! Furthermore, in comparison with pictures, sculpture is really easier to place in a room; you carry it into the room and put it down where you want it. While with a picture, after finding the place for it, there is all the bother of putting wires and hooks on it, pounding nails in the walls, being sure that it hangs straight! Also, from the standpoint of the good housekeeper, a picture once placed cannot be easily moved; there is an unsightly nail hole to be repaired, the wall paper has either a rim of dust around it or has not faded where the picture was hanging. Consequently pictures that are once hung usually stay put. But sculpture can be moved at will from place to place.

The natural liking people have for sculpture is constantly brought to my attention. When coming into a room they rarely mention the pictures on the walls, but they almost invariably notice the sculpture and ask if they may touch it. Often someone will say, "I've always liked sculpture but never have been able to find a place for it in my home."

153

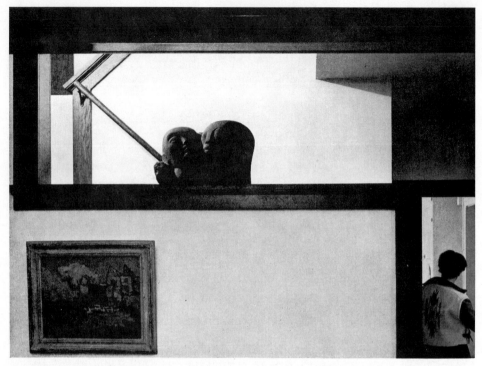

Plate 115. Adam and Eve, by Ann Wolfe.

Let us try to find a few solutions for this problem and see if we can make sculpture easier to use. To begin with we will not limit ourselves to sculpture in wood, since sculpture in other materials is slightly more difficult to place and I should like to show that even more difficult pieces can be used effectively. For instance in Plate 115, notice how imaginatively Ann Wolfe's Adam and Eve, in red sandstone, has been placed. Your immediate reaction may be, "Oh, but how few of us have such a setting — a beautiful modern staircase, like a Mondrian painting!" Look more closely at the picture. It is not a beautiful modern staircase at all, but only appears so because of the treatment! This is the stairway in a bungalow which is no more unusual than thousands of other such dwellings in the city of Minneapolis. But the walls are painted a plain light color, the woodwork dark, and the sculpture thus placed gives style to an otherwise uninteresting front hallway.

154

Plate 116 shows another treatment of an entrance hall. Peter Lupori's ceramic Visitation stands on a long cabinet with one light above to dramatize the figure. Another use of sculpture is the brass bolt on the cabinet, designed and executed by Philip Morton, one of my colleagues at the University of Minnesota.

Plate 117 shows Dorothea Greenbaum's David in a window with plants on both sides. Blot out the figure and notice how uninteresting the window becomes with only the plants. Also notice the other sculpture in the room: a small bronze by Maillol on the left, two ducks on the right, and in the top section of the bookshelves another figure. Mentally remove these pieces of sculpture and you have a pleasant Georgetown living room, in good taste, for it was arranged by an artist, but not nearly as interesting or distinguished a room as it is with the sculpture. This picture demonstrates an-

Plate 116. Visitation, by Peter Lupori.

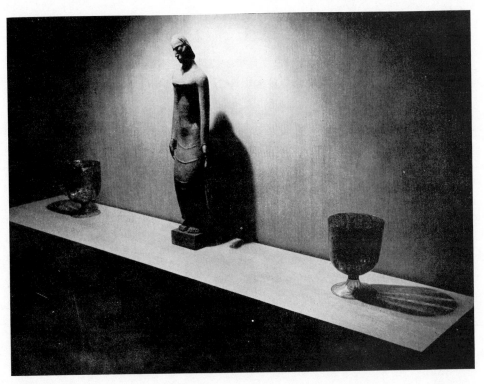

155

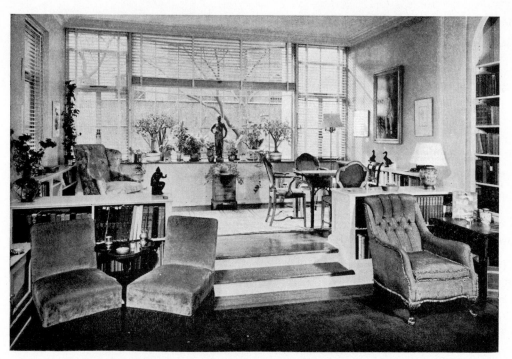

Plate 117. David (in window), by Dorothea Greenbaum.

other point of mine: remove the pictures from the room and the loss would scarcely be noticed! Pictures are apt to become a mere pattern on the wall that can be ignored, but one cannot ignore a piece of sculpture.

Plate 118 shows a flying figure in aluminum by Gwen Lux. It is hung on a dark wall above a sofa. The placing here is important. If the figure had been hung in the exact center of the space it would lose a great deal of its effectiveness. Again notice that this sculpture is not in an unusual setting; it appears so because of the imaginative treatment of the surroundings — a plain wall, a curtain, a sofa, and some cushions. The same can be found in almost every living room in America! And yet, because this wall is dark, because the cushions are of varying intensities of light and dark, because there is a piece of sculpture on that wall, the room has charm and distinction.

Already you are saying, "But the cost! Who can afford to buy a piece of sculpture?" My answer is that sculpture is not nearly so expensive as you

156

may think. The next time you go to an exhibition of painting and sculpture, compare the prices. You will find much sculpture in the price range of fifty to three hundred dollars. You will find the price range of pictures somewhat higher. But beyond that, compare the cost of a piece of sculpture with a piece of furniture. How much do you pay for a radio-phonograph? How much for a piano? How much for a chair, a sofa, a rug? "But," you will counter, "one *has* to have these things." My argument is that if you will do without one of them and buy a piece of sculpture, your whole room will be brought to life, revitalized! No one piece of furniture will do for a room what one piece of sculpture will do; furthermore, most rooms are greatly over-furnished. So, keep this in mind: *you need a piece of sculpture more than a piece of furniture!*

In Plate 119 my Woman with Hen, carved in walnut, is placed on an old English chest. Notice that this figure, carved in the modern idiom, though not abstract, is quite at home not only with the eighteenth-century chest but also with the twentieth-century chair at the right. In such things there is no "period." Good things are good at any time. And yet, the figure is the object in this picture that bridges the gap between the centuries. Take it out of the picture and immediately the chair and chest begin to quarrel with each other!

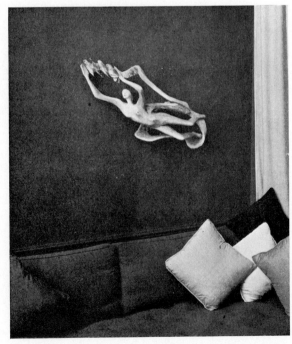

Plate 118. Flying Figure, by Gwen Lux.

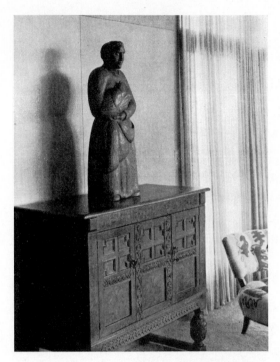

Plate 119. Woman with Hen,
by John Rood.

Plate 120. Woman with Bowl,
by Evelyn Raymond.

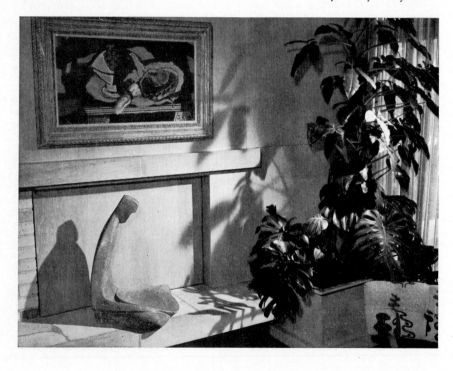

Now let us move gradually outdoors. In Plate 120 Evelyn Raymond's Woman with Bowl is placed on a fireplace ledge. This is in the same room with the Woman with Hen. A chair similar to the one shown in Plate 119 appears at the lower right. This chair with its pattern suggesting plant forms, ties in with the plants in the picture, and from there the eye goes quite naturally to the Braque Still Life and down to the figure on the hearth. And the figure, in cast stone, suggests the outdoors just as the plant does. Then we notice the sunlight streaming in through the window, and gazing outside our eye falls upon other planting and other sculpture. Zorach's Figure of Child in lead, Plate 121, might be just around the corner of the wall. Imagine how uninteresting this corner would be without the figure. We would never look at it twice. But with the figure there, we look again and again and are pleased. Even at night, with a spotlight trained on her, the little girl smiles rather enigmatically and seems a little friend always ready to welcome us.

And now let me show you how very easy it is, really, to use a piece of sculpture. We shall use as an example my Choir Singer. She is carved in ash and slightly bleached so the light color will be retained, as otherwise the wood darkens with age and the strongly marked grain would in time interfere with the shape of the figure.

The Choir Singer, about twenty-one inches high, stands on a block of wood beside the fireplace in Plate 122. She is placed just enough to one side that she may not get too hot from the fire, but not so far that

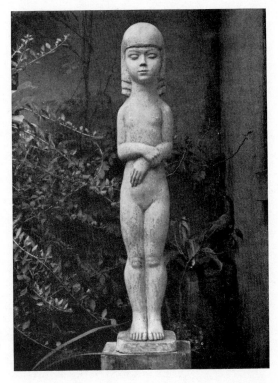

Plate 121. Figure of Child, by William Zorach.

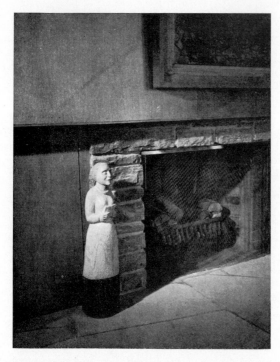

Plate 122. Choir Singer
by fireplace.

the firelight will miss her. This is in a small upstairs sitting room, and in winter evenings, when the fire is lighted, the little singer seems to come to life and almost to move as the reflections of light and shadow play across her face.

In Plate 123 she is on a table at the top of the stairway. She can be seen from all sides as one goes from room to room. Take her away and the upstairs hallway is a passageway, nothing more. But when she stands there, one stops to smile at the almost humorous seriousness of the little figure, so prim and righteous! And in passing, one's hand goes out naturally to give her a pat.

Now in Plate 124 she has moved into a bedroom and stands on a table. The clock says twenty-nine minutes past eleven, but the little singer is on the job all the time. She sings you to sleep and when you waken in the morning, there she is to greet you! And notice, too, the other piece of sculpture on the table, a Sleeping Pup in apple wood. Everything is there for your comfort — the lamp, the clock, the matches and ash tray, the writing

160

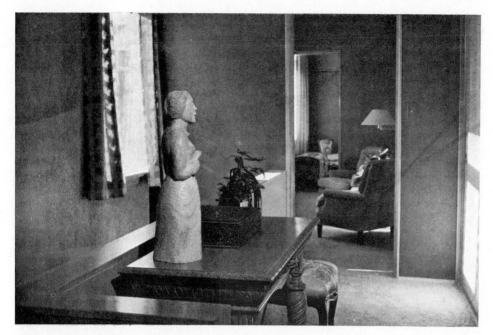

Plate 123. Choir Singer on hall table.

Plate 124. Choir Singer on bedside table.

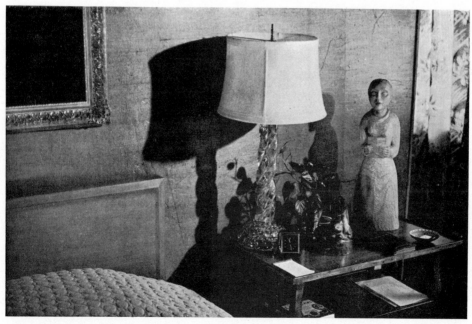

161

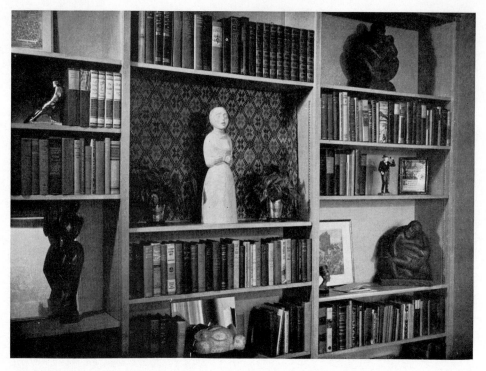

Plate 125. Choir Singer in bookcase.

pad, books to read — but there still is plenty of room for two pieces of sculpture.

Plate 125 shows sculpture making a pattern in empty bookshelf spaces. Eight pieces of sculpture are in this one end of a room! No one of them is large or expensive, but together they reflect the interests and tastes of the owner, creating an atmosphere which painting alone could not give. Remove any one of them and there would be a certain loss. Notice the variety of materials: beginning at top left is a bird in silver, and below that my Night Flower in ebony, then the Choir Singer singing more lustily now so that she may hold her place among the others. Below in alabaster is Alice Decker's Rabbits; then at the top right is Lullabye in mahogany, below that a ceramic figurine of Winston Churchill, then Nefratete, who never looked prouder even though reduced to so small a scale, perhaps for the reason that on the same shelf with her is Jacob Wrestling with the Angel. Who

162

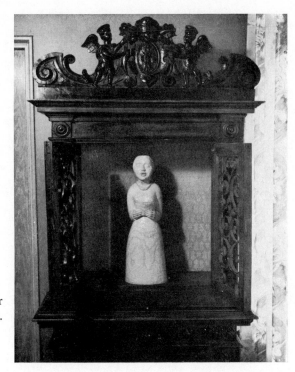

Plate 126. Choir Singer
in Italian cabinet.

knows but that by now she has realized that Jacob's son Joseph is to come to power in her own Egypt!

And then in Plate 126 we move the Choir Singer to a niche where she is the sole attraction. Here she stands in an old Italian cabinet, but seems to feel not at all out of time or place. And, like her sister with the hen in Plate 119, again we see a piece of sculpture bridging the gap of centuries so that the antique and the modern live happily under the same roof.

We could go on almost endlessly. The Choir Singer would add equally to one's happiness if she were placed on the radio, the dining table, the mantelpiece, or on your writing desk. And of course there is always the top of the piano!

So far in this chapter we have been talking mostly about how the average person, who likes sculpture, may use it effectively in his own home and get real enjoyment out of it. There are often times when the uses to which

163

sculpture may be put are not so informal and when the suggestions as to its use are practically requirements. In this I am speaking of commissions — a most welcome thing to artists. It is natural for persons giving commissions to dictate to some extent what they wish. They know how the sculpture is to be used and it is up to the artist to create the right thing for that use.

I should not discuss this here except that I am often surprised at sculptors, particularly young ones, who profess not to like commissions unless they are given absolute freedom in the choice of subject, size, material, and style of execution. Obviously it would be an ideal situation for the sculptor to be told to go ahead and produce anything he liked. However, most patrons know fairly well the sort of thing they want. The patron's idea may be a limitation, but sculpture inherently has many physical limitations which it is the business of the sculptor to surmount. Thus one more limitation, even were it a large one, should be a challenge. Discipline is a good thing and without limitations there would be no necessity for the rigid discipline which is necessary for an artist's growth. In any case, an occasional compromise, even an occasional piece of work the sculptor considers pretty bad, is not going to wreck his reputation. He may wince every time he sees the work or is reminded of it, but in my own case I find that these "turkeys" have probably contributed more to my development than the things I consider pretty good. For every time I hear of or see the thing, I grit my mental teeth. "You can do better than that. You've *got* to do better than that!" I say to myself at those times when I take myself to task — in my case, usually while shaving! I wonder if everyone lectures himself thus in the bathroom, shaking his finger at the serious face in the mirror!

But to get back to our subject: I am, of course, speaking of sensible commissions. Occasionally one is asked to do something that is ridiculous, such as the time I was asked by a woman of kindest intentions to copy a monstrosity of a Victorian wall bracket, complete with simpering head of a girl. She announced with an air of generosity that she was willing to pay me ten dollars for the job. I was tempted to tell her that I would pay *her* ten dollars if she would allow me to smash the horrible thing she wished me to copy.

164

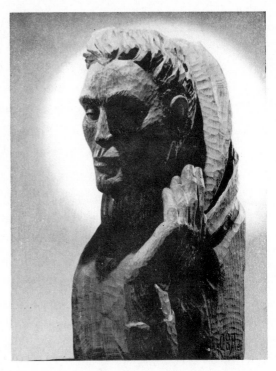

Plate 127. Class of '47. Oak,
1947. About 30 inches.

Plate 127, Class of '47, was a commission
which gave me great pleasure for many
reasons. In late May of 1947 the president
of the senior class at Ohio University came
to me and said that the class would like to
leave a memorial for the men of their class
who had lost their lives in the war. He
asked how much it would cost and when
I named a price he said, "I'm sorry, but
we'll never be able to get that much." I
hastened to assure him that I would do the
work for any amount they could pay, be-
cause it was for me, too, an opportunity to
remember many of my friends who had
been in that class. "Can you possibly get it done for Class Day, next week?"
he asked. That made it even more exciting! "I'll make it in that piece of
wood right there," I said, pointing to a block of oak in the corner of my
studio. That particular piece of oak had been there for several years and
for one reason or another I never had carved it. "And what about a pedestal
for it?" he asked. I assured him that somehow we would get a proper pedes-
tal for the sculpture. Then the matter of payment, "We're having a dance
to raise money," he said. "I'm almost certain it will be four or five hundred
dollars, but I can't guarantee it." I assured him that any amount they might
raise would be satisfactory.

He got up from his chair and I said quickly, "Oh, one thing before you
go. Will you help me place the block on my work bench?" We heaved the
heavy block in place and I began work almost before he was out the door.

For even as we were talking my mind was busy with what was to be
carved in the block. Already in my mind I saw Frank and Ed and Joe, all

165

aviators. One had gone on a solo flight into the mountains and disappeared; another was lost over the Mediterranean; another in the Pacific. And there were many others. I could see their faces. Most of them at one time or another had been there in the studio. And now they came back to tell me what they wanted in this simple memorial. "None of that hero stuff. Just like we were saying 'Hiyuh, Bud!' You know. The kids are going to pass this statue as they go to and from class and we'd just like to be there and give them a little salute."

Thus it was done. The not too serious face, half smiling; the hand raised in the gesture that I had so often seen on campus; the folds of cloth behind the head lifted as it were by the wind, suggesting flight or wings. The sculpture was done within the week and a carpenter made the pedestal for it. Everyone was happy. As I remember, the dance to pay for the sculpture was held a few days after the dedication. The morning after the dance, a rather crestfallen young man appeared at my studio with a shoe box in which was my fee. "We didn't get as much as we expected," he said. "It was a bad night." He counted the money and there was something like one hundred and nineteen dollars and twenty-three cents! It took me some time to assure him that if necessary I would have done the memorial for half that amount.

Perhaps the most interesting commission I have ever had was Creche,

Plate 128. Creche. Figures in polychromed linden. Screen in gilded walnut. 1947.

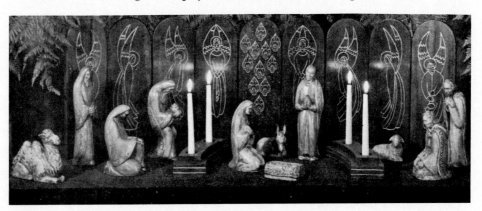

166

Plate 128. When I was first asked to make the creche I was in doubt as to how it could be done with dignity, seriousness, artistic integrity. It was certainly a challenging project. The only creches I had seen were the cheap little plaster ones sold in gift stores at Christmas time. These creches are made up of the characters of the nativity, animals, angels, all huddled together under a straw-thatched hut with no seeming regard for scale or overall design. In fact, I had never seen a creche that was a fine thing from an artistic standpoint; sentiment was there, but not much else. Naturally I did not wish to perpetuate an artistic monstrosity — yet, how could it be done in a moving, sincere way?

The project occupied my thoughts for some weeks before I began work. In the first place, I wished to portray a miraculous happening, a legend, a fairy tale, if you will. I did not want the individual figures or the concept as a whole to be cute or coy as they so often are: the Joseph, the Mary, the shepherds, staring upward with fatuous grins on their faces; the sweet little thatched hut, actual straw in the manger. Although I knew that the wise men did not arrive on the scene until some time after the shepherds, I nevertheless wanted to include them so that the idea of The Child's recognition by king and peasant alike would be implied.

Another thing in most creches that had distressed me was the presence of unearthly beings, angels, on the same level with earthly creatures. And yet there must be a chorus of angels! In solving this problem of the angels' presence I struck upon my entire concept of the scene. Why not remove the angels by making a screen of dark wood on which the angels could be carved in very low relief, their outlines gilded? This served a double purpose: it would separate the characters of heaven and earth and would do away with the awkward and cumbersome stable. Once I had arrived at this solution the rest of the conception came readily.

The figures were carved in linden wood to the same scale, the tallest about a foot high. They were so placed that when all were assembled they made a three-dimensional design. Notice, for instance, the tall wise man at the left, then the one on his knees, and the third one slightly bent as he proffers his gift. Mary is kneeling in an attitude of adoration, while Joseph

167

stands opposite her — a much younger Joseph than is usually depicted. Of course he must have had a beard, since he was a young Jew, but I wished to give him special beauty and grace, therefore eliminated the beard. The shepherds, called in from their flocks, were made slightly more natural than the wise men. This seemed to me right. The wise men, drawn to this miracle out of some curiosity, are impressed and have come bearing gifts. But the lowly shepherds are dumbfounded by what they have heard and are now seeing. They are too poor to bring gifts of gold and incense but bring the best that they have, simple belief and adoration. The older one leans on his staff and stares at the babe; the younger one has fallen to his knees in aston-ishment. The animals sit about with no great interest — after all, they are animals and the miracles of the human race have no meaning to them. Notice that they all are lying down. I have been asked why the camel, at least, is not standing. The reason for this seems obvious to me: if he were standing, because of his size and height, he would dominate the scene.

When I finished carving the figures, I coated them with gesso and poly-chromed them. At first they were too bright. Many of my friends who saw them with the garish colors thought they should be left so, their idea being that the nativity should give a certain childish delight. But to me this was wrong. The creche should be lyrical, poetic, removed from us as is any legend. So I rubbed the figures with steel wool until only a suggestion of color was left. In candlelight, the entire scene blends together like an old French tapestry — touches of gilt on the figures catch the light softly, the angels glow on the dark background.

It has interested me greatly to notice the reaction of people to the creche. Even those who are non-believers, who cannot accept the idea of the miraculous birth, come away from the creche with a certain reverence. Very humble people as well as those of considerable intellectual achieve-ment seem to be equally stirred and uplifted emotionally. What more can an artist expect from his work?

Lately I was asked to execute two figures in wood for Our Lady of Grace, Roman Catholic chapel in Edina, Minnesota. Now, as any sculptor

168

Plate 129. Our Lady of Grace.
Linden, 1949. 4½ feet.

knows, church commissions are perhaps
the most difficult of all, for not only the
priest or minister must be satisfied, but
also the members of his congregation.
Thus it was that when Father Louis For-
rey spoke to me first about the figures,
he said, "You may not be interested in
doing the work at all, for if we are to ac-
cept them the figures cannot be as mod-
ern as most of your work." Yet the only
limitations placed on me were that "Our
Lady" must have her hands extended
and her gaze, as well as that of St. Jo-
seph, must be downward. Our Lady of Grace, Plate 129, was completed first
and my wife and I took it to the chapel in the station wagon. At the chapel
we found a fairly large group of women waiting to see the figure. They had
no idea what to expect and when the figure was in place and the cloth in
which it was wrapped was removed, there was an audible gasp. A few of
the women liked the figure, but the majority of them did not. "I had ex-
pected one of those little colored figures such as I used to see in the church
when I was a girl," one of them said. Others said, "But you've made an *old*
woman!" Still others, "Those great big coarse hands!"

"Don't worry," Father Forrey said to me. "They will all grow to love her
and eventually will be very proud that she is here."

One of the women overheard him and commented rather grumpily,
"Maybe so, but it certainly isn't what I expected."

After the shock of Our Lady of Grace, the St. Joseph, Plate 130, was
accepted without reservation. Already, I have been told, the congregation
is happy with both figures.

Plate 130. St. Joseph.
Linden, 1949. 4½ feet.

Plate 131. Mother Cabrini, by Alonzo Hauser.

I do not believe that my friend Alonzo Hauser had such "commission difficulties" with the figures of the Virgin Mary and Mother Cabrini which he carved in oak for the Church of St. Francis Xavier Cabrini in Minneapolis. Plate 131 shows the Mother Cabrini. It is slightly over life size.

Then there is a minor aspect to the business of being a sculptor, particularly a sculptor in wood. This is creating objects for the fun of it! The Fish, Plate 132, is an example. This was never intended as a serious work of art; it was made as a Christmas present for my step-son. He had recently returned from a fishing trip to Florida, during which he caught a nine-foot marlin. Fred's "fish story" caused much joking among members of the family. The innocent little dolphin-like carving contributed to the hilarity of Christmas and has become one of Fred's most cherished possessions. As he says to me, "When you carve something else as good as my fish, I'll think you're really amounting to something!"

Sven and Helga, Plate 133, were carved two summers ago. My wife and I were building a small cabin on the north shore of Lake Superior. That cabin will always have a special place in our affections because so much personal effort went into its building. When we began it in early summer,

Plate 132. Fish. Walnut, 1947. 12 inches.

Plate 133. Sven and Helga.
Birch, colored, 1948.
About 18 inches.

everyone said, "Won't it be nice next year." But we insisted, it will be finished within two months and we are going to have two weeks in it before we go back to town. "Impossible!" the natives said. Our friends merely smiled with pity. Quite obviously we had never built a house before!

Work was begun immediately after the Fourth of July. The garage was built first so that the carpenters who came from Wisconsin might live in it while building the cabin. We had no contractor in the usual sense, merely the four carpenters, one of whom was foreman. I guess my wife and I were co-contractors! In any case, we were the first on the job in the morning and the last at night. I broke up stones for the foundation, carried water for cement mixing, was there to interpret the rather casual architect's drawing we were using for a plan. Whenever there was a shortage of materials, Dorothy drove the station wagon to Grand Marais, a distance of some twenty miles, for whatever was needed. One day she drove in with

172

the back end so heavily laden with bags of cement, nails, and hardware that the car — always a bit top-heavy when overloaded — careened to a rather dangerous degree. But more than this, roped to the top were lengths of flooring which overhung front and back to such an extent that it was almost impossible to see from the driver's seat! Whoever turned her loose on the highway with such a load must either have been out of his mind, else unable to resist a woman's very special powers of persuasion! In any case, on August 14 we moved into the cabin, just five weeks from the time we broke ground.

From the beginning of our plans we had talked about some sort of sculpture that would mark the cabin as our own. We had a heavy oak beam, nine feet long, put into the chimney as a mantel with the idea of having it eventually become a pictorial history of our life on the north shore. On it I would carve important dates and animals as we saw them. Of course August 14, 1948, our first night spent in the cabin, was the first thing to be carved in the beam, along with our initials and a bunch of grapes for happiness and all good things; then followed a rabbit, a chipmunk, a grouse, three deer. There is no bear yet, but we are hoping it can be carved soon. One of the rules is that no animal can be carved into the mantel unless we both see it! This complicates matters a bit. But eventually the bear — and who knows, perhaps a cub! — a porcupine, and a beaver can be added.

But somehow this mantel shelf was not enough. When we came each summer to the cabin we wanted our Lares and Penates, our own household gods, there to greet us. So one day I went up to the work bench in the garage and set to work on a log of our own birch. I carved Helga in the morning and Sven in the afternoon. When they were finished, I painted them with the same gay, primitive colors we had used in the decoration of the cabin: blue, red, yellow. Now they stand inside the doorway of the cabin, greeting us and our friends when we open the door.

As I said before, this sort of sculpture is in no way serious as a work of art but such works give much pleasure to everyone concerned.

At the present, in my spare time, I am making the signs of the zodiac which will be partially polychromed and serve as a decoration for my new

studio. (See frontispiece for Signs of the Zodiac in place.) As time goes on, I hope always to make these decorative, "just for fun" sculptures. What's the fun of being a sculptor unless one can occasionally go on an artistic spree!

I suppose a book such as this should end on a high, noble plane, with resounding words to ring in the reader's mind. But to me, somehow this does not seem that sort of book. Everything has been said as simply and sincerely as I know how to say it. Perhaps tomorrow or next year I shall not agree with some of the ideas herein expressed because with growth and change one's ideas are bound to grow and change. But for the present the ideas expressed represent my sincere belief.

My hope is that through this book I may have interested many people in the making of sculpture. It is really not as difficult as it may sound: I should know for I have taught hundreds of boys and girls, men and women, to make sculpture in wood. Women, especially, are often under the delusion that physically they are not strong enough. But excluding my own work, you have seen in these pages sculpture by as many women as by men. It is not too difficult a medium for anyone of normal strength.

Quite as important as awakening interest in the making of sculpture, I hope that through this book I may have led many people to a better understanding of art and the way an artist works. I have tried to show that this understanding is not too difficult to acquire if one is willing to forget some of the false preconceptions and prejudices that exist and to use instead the God-given talent, imagination.

Finally, and this is not a selfish wish, but rather a desire to have others share my pleasure, I hope that these pages may have filled you with the desire to own, to use, and to enjoy sculpture in your own home, your office, or even perhaps to commission a sculptor to carve something for a public building.

Appendix

MATERIALS

Tools: Buck Brothers, Riverlin Works, Millbury, Mass., for carving tools
Sculpture House, 38 East 30th Street, New York, N. Y., for complete sup-
plies. Local hardware stores for carpenter's chisels and gouges, sharpening
stones, general supplies. H. & H. Grinding Co., 2127 East 2nd Street, Cleve-
land, Ohio, for expert sharpening and grinding.

Wood: Albert Constantine and Son, 2050 Eastchester Road, New York
61, N.Y. Local lumber dealers for native woods such as walnut, oak, bass (or
linden), pine, cherry. Try your firewood dealer for logs.

REFERENCE BOOKS

BRIDGMAN, GEORGE B., *Constructive Anatomy*, Bridgman Publishers, Inc.,
Pelham, N.Y.

CARLS, CARL DIETRICH, *Ernst Barlach*, Rembrandt-Verlag, Berlin.

CALDERON, WM. FRANK, *Animal Drawing and Anatomy*, Charles Scribner's
Sons, 1928.

DURST, ALAN, *Wood Carving*, The Studio, Ltd.

HOFFMAN, MALVINA, *Heads and Tails*, Charles Scribner's Sons, 1936.

HOFFMAN, MALVINA, *Sculpture Inside and Out*, W. W. Norton & Co., 1939.

MACNAB, IAIN, *Figure Drawing*, The Studio, Ltd., 1936.

MESTROVIC, IVAN, *The Sculpture of Mestrovic*, Syracuse University Press, 1948.

NICOLAIDES, KIMON, *The Natural Way To Draw*, Houghton Mifflin Co., Boston, 1941.

PUTNAM, BRENDA, *The Sculptor's Way*, Farrar & Rinehart, Inc., New York, 1939.

RICH, JACK, *Materials and Methods of Sculpture*, Oxford University Press, 1947.

TANGERMAN, E. J., *Whittling and Woodcarving*, Whittlesey House, New York, 1936.

ZORACH, WILLIAM, *Zorach Explains Sculpture*, American Artists Group, N.Y.

Index

Accordion Player, 136, 137
Accused, The, 17, 18
American Association of University
 Women, 19
American Youth, 36
Appleseed, Johnny, 25, 28, 29, 30
Arrogance, 100, 101
Art: value of, 4; as a necessity, 5; func-
 tion of, 5; progress in, 5; as inter-
 national language, 6
Athlete's Head, 35
Atlantic Monthly, 28

Barlach, Ernst: Revenge, 82; Peasant
 Girl, 86, 87
Baroque Form, 61
Beckmann, Max, 11
Beethoven, Ludwig van, 8, 33
Benton, Thomas Hart, 21
Big Boss, 57, 58
Bird, 65, 66
Boogie-Woogie Boys, 36, 37
Boone, Daniel, 21
Brancusi, Constantin, 87
Brown, John, 21, 22, 25, 35
Brummé, C. Ludwig, 68: Salome, 67

Brushes, cleaning of, 137, 138
Buchholz Gallery, 86
Buckeye Country, The, 28
Burning Bush, 149

Camel, 120
Caryatid, 140, 141
Cat, The, 62, 63
Cézanne, Paul, 11
Chicago Art Institute, 86
Choir Singer, 159–63
Class of '47, 165
Classical Head, 96, 98
Cockfighter, 132, 133, 138
Commissions, 164
Creche, 166–68

Daumier, Honoré, 6
Decker, Alice: Rabbits, 162
de Creeft, José, 84: Salammbo, 85; Ni-
 geria, 130, 131
del Prado, Maria Nunez, 25: Miners, 24
Dombek, Blanche, 68: Defiance. 67
Draper, Ruth, 28
Drawing, 69–71
Durst, Alan, 44

177

Elephant Form, 119
Elgin Marbles, 114
Embrace, 124
Eroica or Waiting Mother, 18, 19, 25, 142

Finishing, 128–51: sandpaper, 128, 134; oil, 128; lacquer, 128, 135, 136, 137; shellac, 128, 142; varnish, 128; tool marks, 129; linseed oil, 140, 142; penetrating oil, 142; olive oil, 142; beeswax, 142, 143, 144; plastic wood, 143, 144; plastic glue, 144; casein glue, 145; polychroming, 146–48; gesso, 146; gold leaf, 147, 148; staining, 148, 149, 150
Fish, 171
Folk Music series, 25, 28
Forrey, Father Louis, 169

Garfinkle, Max, 89–93
Gill, Eric, 5, 6
Goin' Home, 38, 39
Goodelman, Aaron, 60: The Rope, 60; Empty Plate, 109; My Kin, 130, 131
Grandmother, 142, 143
Greco, El, 11
Greenbaum, Dorothy, 155: David, 156
Gross, Chaim, 86: Tumblers, 85; Acrobatic Dance, 85

Harp, 148
Hatcher, Harlan, 28
Hauser, Alonzo, 171: Mother Cabrini, 170
Hebald, Milton, 127: Girl with Birds, 126
Henry, John, 28, 132, 133, 137
Herculaneum, 8
Homage to Mae West, 125
Horse, 65, 66

Jacob Wrestling with the Angel, 71, 162
Jones, Casey, 22, 24, 25

King, Bernice, 65: Abstraction, 66

Lamination, 127

Laocoön, 71, 72
Laughing Man, 131
Leaping Horses, 147, 148
Lullabye, 162
Lupori, Peter, 116: Pieta, 117; Visitation, 155
Lux, Gwen, 156: Flying Figure, 157

Maillol, Aristide, 155
Man with a Rake, 72, 88
Mandolin Player, 115
Matisse, Henri, 11
Mestrovic, Ivan, 113, 114
Michelangelo, 9
Mondrian, Piet, 154
Morton, Philip, 155
Mountaineer's Wife, 21, 22
Museum of Modern Art, 86
Mussolini, Benito, 30

Nativity, altar piece, 115, 149
Night Flower, 62, 63, 139, 160
Novice, The, 111, 137

Our Lady of Grace, 169

Patriarch, 105
Paul Bunyan, 28
Picasso, Pablo, 11
Polychrome, 116, 146–48
Pompeii, 8
Praying Woman, 27
Preacher, 126
Proportions, 62
Proud Mother, 28, 29

Queen of Heaven, The, triptych, 115, 149

Race, 96, 97
Raymond, Evelyn, 159: Woman with Bowl, 158
Resurrection, 150
Return of John Brown, 16
Rouault, Georges, 11

St. Anthony, Temptation of, 146, 147
St. Joseph, 169, 170

Signs of the Zodiac, frontispiece, 173, 174

Silent People, 131

Skygazer, 87

Sleeping Pup, 160

Slow Dancer, 139

Smart, Charles Allen, 28

Smasher, 30, 31

Studio, *frontispiece*, 43, 174: lighting of, 47

Sven and Helga, 171, 172, 173

Tools: chisels, 16, 45, 78; gouges, 16, 45; vise, 42, 43; hand screw, 42; mallet, 44; rasps, 44, 62; gloves, 45, 62; sharpening stones, 45; V or parting tool, 45; veiner, 46; fish tail chisel, 46; carving sets, 46; sandpaper, 65; rack for, 48; sharpening of, 49–55; work bench, 42, 43

Torch Singer, 128, 129

Torso, 57, 58

Toulouse-Lautrec, 6, 7

Tumblers, 122: drawing of, 123

War and Peace, 7

West, Homage to Mae, 125

Weyhe Galleries, 86

Wheelock, Warren, 68: Resignation, 67

Wolfe, Ann: Adam and Eve, 154

Woman with Bare Feet, 109

Woman with Hen, 157, 158

Wood, Grant, 21

Wood: cracking or checking of, 16, 142; choice of, 39; grain in, 84. *Kinds of*: pine, 15, 21; poplar, 15; oak, 15, 19, 21, 35, 38; cherry, 19, 21, 35, 36, 140; walnut, 19, 21, 35, 140; apple, 21, 35, 140, 149, 160; cedar, 21; hickory, 21; butternut, 21; pear, 21, 35, 36, 140; ebony, 24, 35, 36, 140; elm, 24, 150; myrtle, 137, 147, 148; lignum vitae, 140; rosewood, 140; teak, 140; snakewood, 140; mahogany, 147; ash, 159

Wright, Frank Lloyd, 21

Young Brunnehilde, 140, 141

Young Girl, 140

Zadkine, Ossip, 24: Christ, 23; Il Pensoroso, 145

Zorach, William, 25, 113: Floating Figure, 23; Figure of Child, 159; Tiger, Tiger, 114